EDITOR IN CHIEF
Patsy Tarr

EDITOR / DESIGNER
J. Abbott Miller

GUEST CO-EDITOR
Judith Hoos Fox

DESIGN ASSOCIATE
Jeremy Hoffman
Pentagram

MANAGING EDITORS
John Porter
Jane Rosch

SENIOR EDITOR / WRITER
Nancy Dalva

NEW MEDIA
Jeff Tarr, Jr.

FOUNDATION ADMINISTRATOR
Michael Bloom

ADVISORY BOARD
Karole Armitage
Victor Barcimanto
Geoffrey Beene
André Bishop
Lewis Black
Trisha Brown
Rika Burnham
Maria Calegari
Elaine Lustig Cohen
Bart Cook
Merce Cunningham
Julie Dale
James Danziger
Leon Dalva
Molissa Fenley
Audrey Friedman
Henry Louis Gates, Jr.
Dorothy Globus
Neil Greenberg
Barbara Horgan
John Jesurun
John Kelly
Wendy Keys
Salvatore La Rosa
Kevin MacKenzie
Peter Martins
Ariel Meyerowitz
Mark Morris
Gregory Mosher
Patricia Pastor
Richard Peña
Stephen Petronio
Jean Pigozzi
Etheleen Staley
Elizabeth Streb
Paul Taylor
Twyla Tharp
Robert Wilson
Taki Wise

2WICE

2wice® is published by the 2wice Arts Foundation, Inc. Financial support is derived from individual, corporate, and foundation contributions and reader subscriptions.

2wice Arts Foundation, Inc., is a tax-exempt organization under section 501(c)(3) of the Internal Revenue Code. Contributions to 2wice Arts Foundation, Inc., are tax deductible to the extent provided by law.

EDITORIAL QUERIES

We consider unsolicited submissions but cannot return or respond to submissions that don't include a self-addressed, stamped return envelope. Please do not send original artwork.

SUBSCRIPTION INFORMATION

one year (2 issues) $40 us $48 foreign

To subscribe or to make changes to an existing subscription, please visit the 2wice website at www.2wice.org or contact us at:

2wice Arts Foundation
9 West 57th Street, Suite 4210
New York NY 10019

phone: 212.826.9600
fax: 212.826.9651
email: info@2wice.org

DISTRIBUTION INFORMATION

2wice is distributed to the book trade by:

Princeton Architectural Press
37 East 7th Street
New York NY 10003

For a free catalog of books, please visit www.papress.com or call 1.800.722.6657

ISBN 1—56898—311—5

© 2001 2wice All Rights Reserved

SURROUNDING INTERIORS

This issue of 2wice is published in conjunction with the exhibition Surrounding Interiors: Views Inside the Car

Organized by the Davis Museum and Cultural Center, Wellesley College
Judith Hoos Fox, curator

Supported by the 2wice Arts Foundation

Museum programs are funded in part by the Institute of Museum and Library Services and the Massachusetts Cultural Council.

Funds for this project have been provided by Wellesley College Friends of Art, Sandra Cohen and David Bakalar Fund for Art, Commercial Vehicle Systems/ Heavy Duty Holdings, Davis Museum and Cultural Center Program Endowed Fund, Constance Rhind '81 Fund for Museum Exhibitions, E. Franklin Robbins Art Museum Fund, June Feinberg Stayman '48 Art Fund, and Judith Blough Wentz '57 Museum Programs Fund.

EXHIBITION ITINERARY

October 5, 2001—January 6, 2002
Museum of Art
Fort Lauderdale, Florida

February 21, 2002—June 9, 2002
Davis Museum and Cultural Center
Wellesley College
Wellesley, Massachusetts

September 7, 2002—January 3, 2003
Frederick R. Weisman Art Museum
University of Minnesota
Minneapolis, Minnesota

ACKNOWLEDGMENTS

Brian Bergman, Roy Brooks, Grayson Dantzic, Barbara Full, Tom Gilbert, Kim Hoang, Jay Hoffman, Johnschen Kudos, Ellen Lupton, Ron Mandelbaum, Richard McDonough, Sue Middleton, Rebecca Mongeon, Sarah Moughty, Cathy Peck, Anne Collins Smith, Laleh Torabi

PRINTED IN THE U.S. BY

Strine Printing Company, Inc.
30 Grumbacher Road, York, PA 17402

PAPER

2wice thanks Donside Paper for their generous support during the past three years. Papers used in this issue: Consort Royal Silk Cover (120lb) and Consort Royal Text (100lb)

FONTS

Text set in FF Info, a font designed by Erik Spiekermann and Ole Schäfer. Headlines set in Bullet, a font designed by Tal Leming for House Industries.

AWARDS

Over the past two years 2wice magazine has been recognized by the following organizations and publications:

American Institute of Graphic Arts Annual Design Competition
American Center for Design Annual 100 Show
Art Directors Club (Distinctive Merit & Merit awards)
British Design and Art Direction
Donside Millenium Award (Award for Magazine Design)
Graphis Design Annual
International Council of Graphic Design Associations (ICOGRADA)
 Brno Biennial (Best Magazine / Newspaper Design)
Print Magazine's Regional Design Annual
Society of Publication Designers (Silver Medal & Merit awards)
Type Directors Club (Certificate of Typographic Excellence)

2wice
VISUAL AND PERFORMING ARTS
VOLUME 5 NUMBER 2

Joseph Mulligan

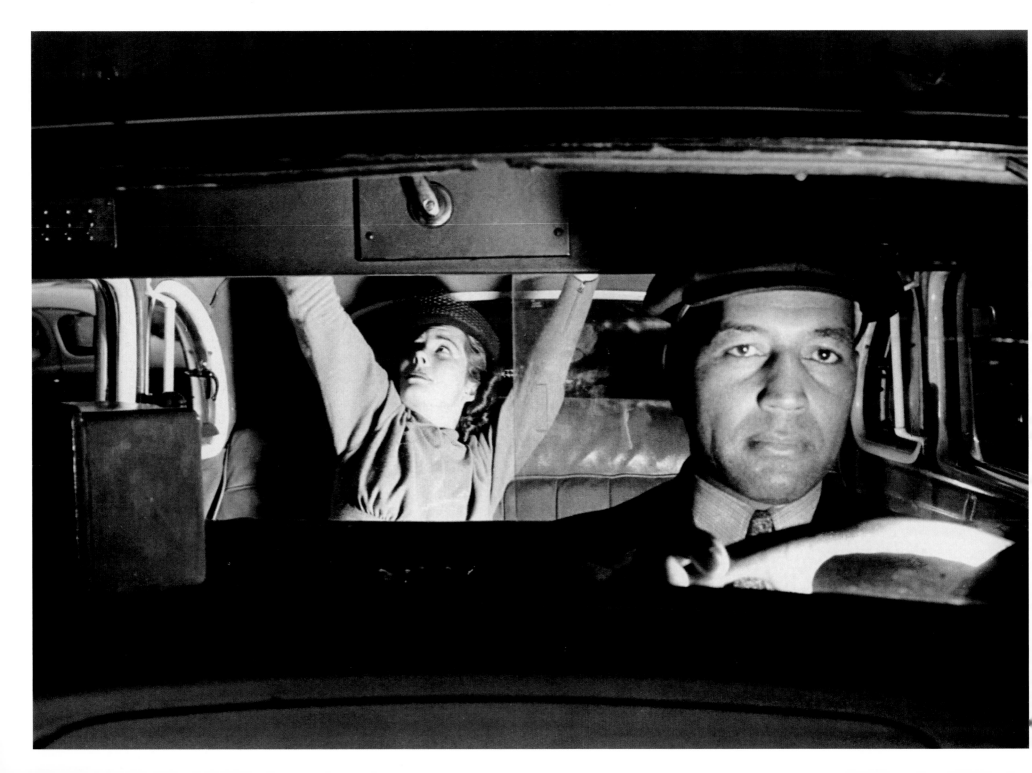

CAR

The automobile is one of the defining technologies of the past century. As the dashboard moves closer to the paradigm of the computer screen, the automation of the driving experience vitiates the distinctive qualities of driving. Still, there is no better way to experience the vastness of the American landscape and to have epic conversations with fellow passengers. Conversation and leisure are the typical attributes of home life, and accordingly, domestic space is increasingly the other paradigm for the design of new car interiors. This issue of *2wice* looks at these psychological and physical aspects of the car interior through the lens of art, design, video, film, and photography.

 We are fortunate to have produced this issue in collaboration with the Davis Museum and Cultural Center of Wellesley College. The Davis's curator of contemporary art, Judith Hoos Fox, initiated the exhibition called "Surrounding Interiors: Views Inside the Car," which this issue of *2wice* parallels. While not a formal catalogue of the exhibition, many of the themes and images presented here appear in the show as well. *2wice* expands upon these ideas by inviting a number of writers to consider the space of the car in a series of provocative essays. The exhibition will travel to three different venues within the US, introducing museum audiences to *2wice* and expanding our approach to presenting work in an interdisciplinary context.

PATSY TARR / J. ABBOTT MILLER

Herbert Gehr, 1938, A woman performing taxi exercises. Photo courtesy Robert Gehr / Black Star / TimePix, NY

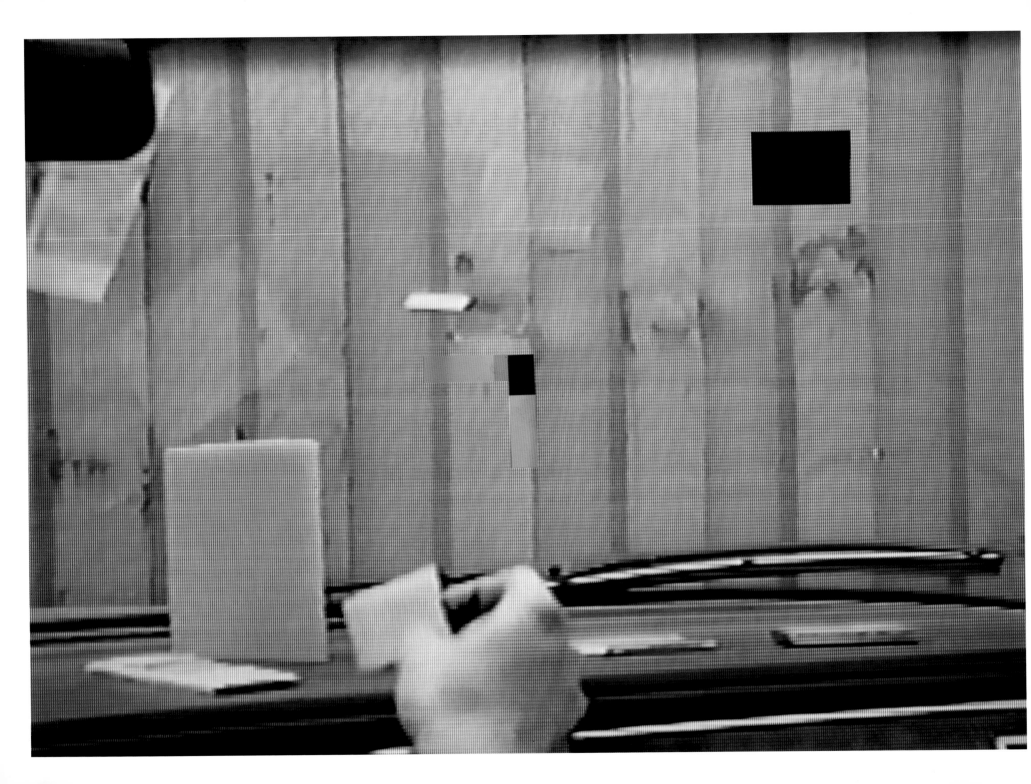

SURROUNDING INTERIORS

JUDITH HOOS FOX

Pablo Picasso, *La guenon et son petit*,
Oct. 1951, mixed metals, © 2001 Estate of
Pablo Picasso / Artists Rights Society (ARS),
New York

Left. Cate Snook, *Untitled*, 1998, single-channel
video in altered monitor

As early as 1917, entranced by the mobile, glass-enclosed space, the car interior, Henri Matisse painted *The Windshield (Road to Villacoublay)*, a tiny work in which he posits the complex nature of this particular space. For Matisse, the car interior is a place of contemplation and creation, a private place offering protection from, yet allowing mastery of, the exterior world. The windshield organizes the visible world into discrete, manageable segments, a literal lens that focuses Matisse's view: vast fields, water and the endless road are contained and framed. Occupying the driver's seat as his surrogate in the painting, a canvas in progress rests against the steering wheel. For Matisse, the car interior is the domain of the artist.

Thirty-four years later, Pablo Picasso, perhaps unwittingly, takes this idea of the car interior as an expression of self even further. The head of his sculpture *La guenon et son petit* is an actual toy automobile. The cranium, brain and nerve center of this near relative of ours assumes the form of a car. The world is seen through the windshield, the eyes of the monkey. The car interior is a cockpit of sorts, a place in which we spend hours — of tedium and of import — navigating from one state to another, geographically as well as psychologically, traversing topographic and emotional terrain.

In these two works of art, the car interior emerges as an analog of the self, a site of psychic activity and expression. Like mental activity, life inside the car unfolds in a realm parallel to the world exterior, moving in tandem or in opposition. In recent decades, as both the number of cars and the amount of time spent inside them has increased, artists have frequently placed themselves within the car, considering the human activity it contains and scanning the world within it and the world without. They have peered into it, manipulated it or reconstructed it in their explorations of self and culture. That so many artists have addressed the subject of the car interior points to the potency of the place and all it evokes. Though the car and highway have repeatedly been the subject of exhibitions, the car interior has been

James Rosenquist, *Highway Temple*, 1979,
oil on board with painted ladder,
© James Rosenquist / Licensed by VAGA, NY

ignored, perhaps too mundane a place to be recognized by critics and curators as a subject. The *Surrounding Interiors* exhibition—and this issue of *2wice*—are the first such projects to explore the nature of this space. The exhibition includes video, sculpture, painting and photography, each work in the exhibition exploring a particular characteristic of this complex space. This issue of *2wice* enlarges the discussion to include music, film, fashion, and the interior design of automobiles.

In naming his painting *The Windshield (Road to Villacoublay)* Matisse characterizes the windshield as a delicate membrane, a mediator between two distinct realities. The video artist Cate Snook traces the fragile connection between these realities—interior thought and the exterior physical world, the inside of the car and the outside—as she drives slowly around an empty parking lot, a video camera affixed to her shoulder and aimed out the front windshield. She rearranges small square blocks set on the dashboard; their alignment seems to correspond to constellations of objects outside the car and to the small pieces of paper she has taped to the screen of the video monitor, tenuous but deliberate connections between interior and exterior, shifting from harmonic to parallel to dissonant.

The anonymity of the car interior provides an ideal site for psychological and social exchange. Blake Rayne's uninflected *Autumn Drive: Part I and Part II* presents the space as a tabula rasa. The car interior is fixed. The choices offered to consumers to personalize their cars' interiors have been remarkably nominal: leather or fabric, tan or gray. The generic predictability of the car interior does not propose any particular behavior; it is a given that does not call for comment, serving as backdrop to its inhabitants' needs. Within its neutral privacy, Kathleen is photographed as she unguardedly mourns Greer's death en route to her funeral, witnessed by her friend, the photographer Nan Goldin. In another Goldin photograph Misty and Jimmy Paulette tensely cross both city limits and gender lines. The terrain traversed

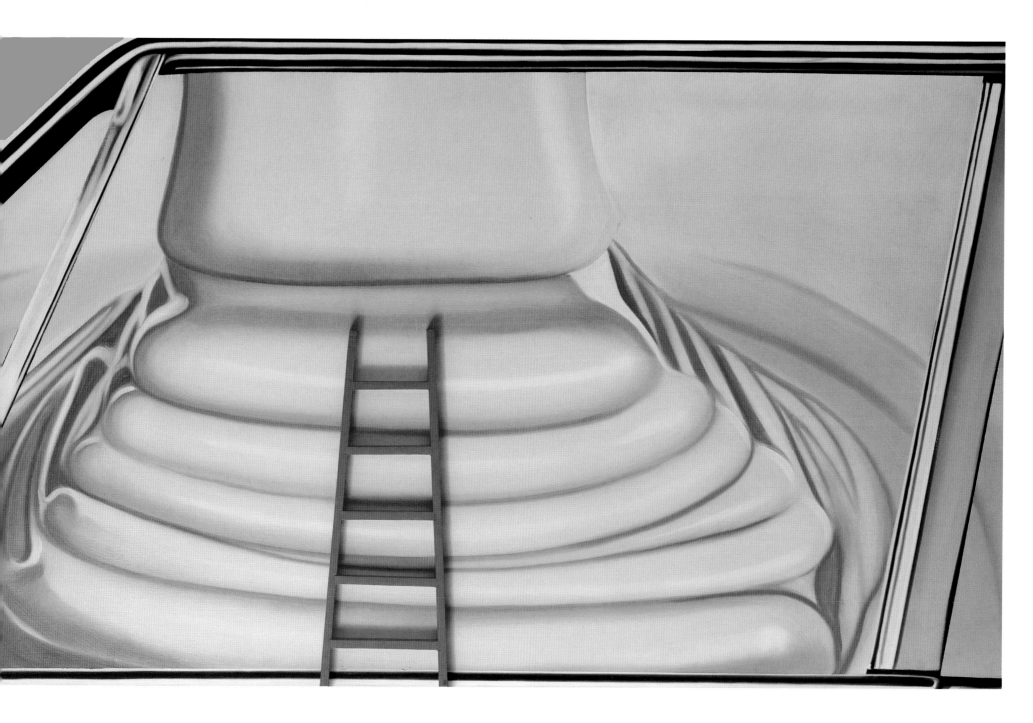

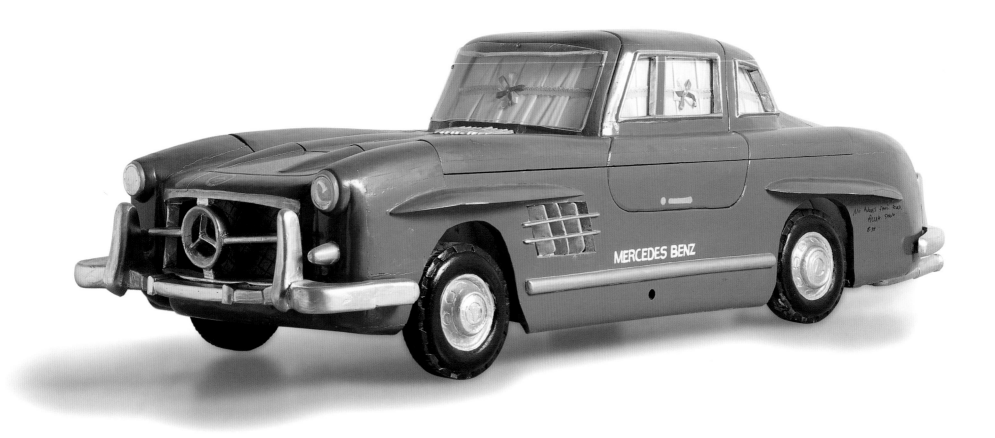

Theophilus Nii Anum Sowah, *300 SL Mercedes*, 1990, wood, paint, bondo

Right. Edward and Nancy Reddin Kienholz, *First Car First Date*, 1992, mixed media

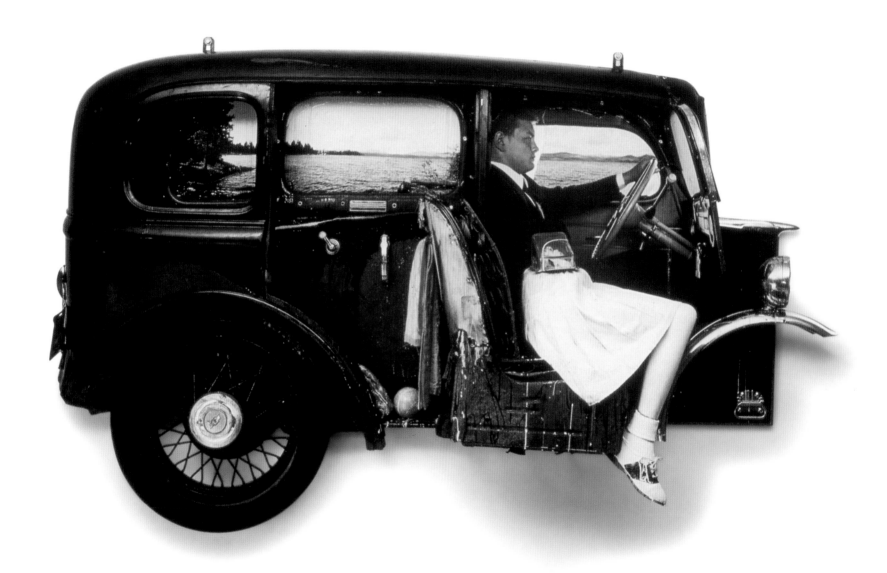

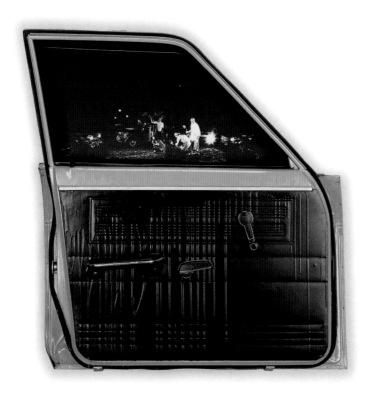

by Sophie Calle and Greg Shephard in the video *Double Blind* is experiential, emotional and sexual as well as geographic. We are privy to these near strangers' unfolding perceptions of each other as they travel together across the United States in Greg's car—infatuation, anticipation, irritation are voiced in Greg's whispers and Sophie's subtitled French. The journey includes their wedding at a drive-through chapel in Las Vegas. The alternating video footage and narratives, as they cross the country, map the trajectory of their relationship.

The neutrality of the car interior is, at times, witness to the expression of emotion. This anonymous shell of vinyl and carpet can become a vessel for the steamy stuff of lived experience. Calle and Shephard have recorded it on video; James Rosenquist depicts it as a viscous liquid, caramel, chocolate or strawberry, filling the car interior. The car is so much more than a means of transportation: it is a locus of intense emotional activity. Within its confines lives are lived. It can offer solitude from telephone, kids and colleagues; it is the only place many of us find ourselves alone. Distinct from the rest of the world it is a place where personal conversations can take place freely—accusations, apologies, explanations, assignations—a place where dreams are imagined and plans are hatched. The car trip can be a psychic journey as well: arrival can signal a new place both mentally and physically.

As life is often prosaically described as a journey, it is not surprising that rites of passage are now often entwined with the possession of a car. In Nancy Reddin and Edward Kienholz's *First Car First Date*, expectations, place and players merge into a single composite: male/female/machine; prim/portentous; anxious/romantic; powerful/vulnerable. The emotions are raw as are the cuts through car and figures that join the interior and exterior of the vehicle to its young driver and passenger. Adolescence, autonomy, independence, adulthood—these are states inextricably linked in this culture to the car.

Edward and Nancy Reddin Kienholz, *Sawdy*, 1972, mixed media assemblage

Left. Peter Cain, *Bonneville*, 1993, cibachrome print

Within the Ghanaian tradition of building polychrome wooden coffins in shapes that celebrate the deceased's life and passions, the car is a popular form. The car provides the means for this final journey; the destination is the afterlife. The size of Theophilus Nii Anum Sowah's *300 SL Mercedes*, somewhere between model and full-scale, is unsettling. These cramped, claustrophobic accommodations identify occupant with container; the car body becomes a shroud.

Intense identification with the car is counter to the idea of the car as an impersonal stage for human expression. The car interior can become a place for the assertion of identity. The wired-together, repainted, vintage American vehicles of Cuba, in Alex Harris's mural-sized photographs, return us to Matisse's image of the car interior as a portrait of the owner/driver. Each of Harris's photographs tells the story of the driver's personal, economic and political life.

The artist Andrea Zittel customized small trailers to the specifications of their owners: a luxurious place to indulge the senses for gallerist Andrea Rosen; for the Shifflers an immersion tank with sound system, a place of isolation and self-absorption. Each trailer is designed to be placed in its owners' living room. Zittel seems to suggest that even in our homes we are not entirely at ease or able to achieve privacy, as if its only inside a vehicle that we can experience security and the freedom to be ourselves.

If the car offers a sense of privacy, it is compromised. The couple in Lorna Simpson's *The Car* feels secluded, but the artist's text makes it clear that we are watching them. The car, a "small cramped room," is a stage set of sorts rather than a shelter, and we are the audience. Andrew Bush's piercing views into vehicles, photographed as he travels alongside in his own car, puncture the illusion of privacy, that protective shield drivers and passengers imagine surrounds them. In art historian Pierre Schneider's discussion of Matisse, he connects the artist's fascination with the car to his delight with goldfish in glass bowls. In our cars we become goldfish: protected, unaware, disengaged. We behave as though we were in seclusion. By literally turning the car inside out, Dan Devine expresses this paradox: what is experienced as private can be exposed. We are uncomfortable when our eyes meet those of passengers traveling in the next lane; children are surprised when their waves are returned. Privacy, shattered, is disconcerting.

The character of the car interior is both dual and contradictory. The privacy it offers is both real and compromised. It is a bland and anonymous space, yet it can become deeply personal. As the car interior is increasingly penetrated by the outside world through cell phones, e-mail, mapping devices, temperature readings, and more, and as our ability to personalize it also increases, its distinctive character recedes. It blends with the spaces of the office, waiting room, and living room. The issues explored by the works in *Surrounding Interiors* may soon seem historical and nostalgic. The media is currently filled with speculation about inventor Dean Kamen's "Ginger" (*Boston Globe*, February 1, 2001). If, as has been speculated, thi snew transportation device is a radical re-thinking of personal mobility, Picasso's *La guenon* is uncannily prescient. Life inside the "car" may become synonymous with the life of the mind, and the images in *Surrounding Interiors* will read as metaphorical.

Dan Devine, *Inside Out Car (White with Brown Interior)*, 1998, Volkswagen car

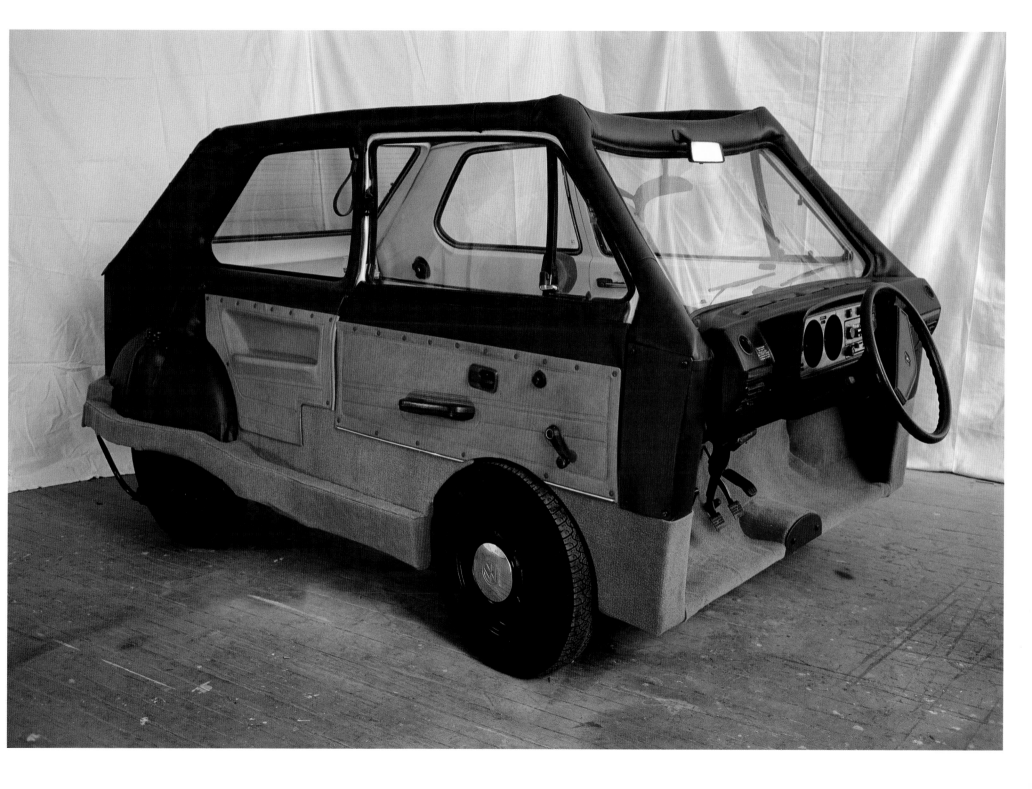

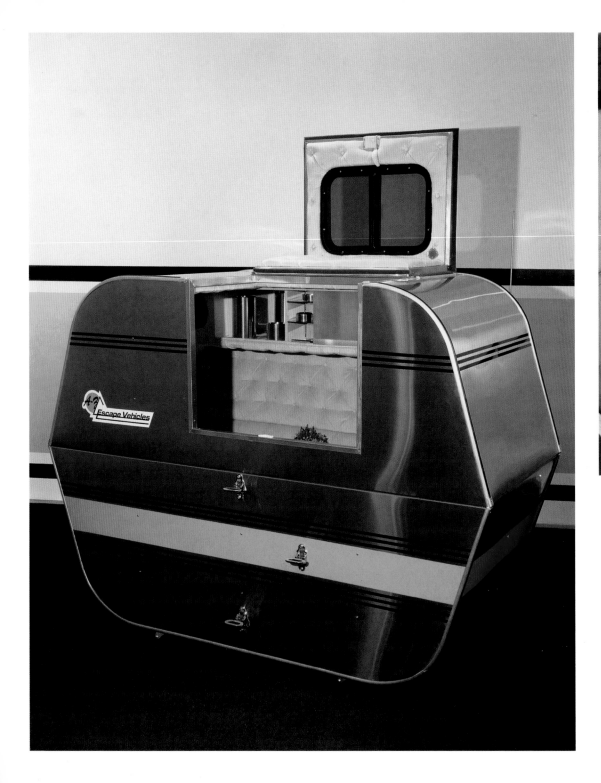
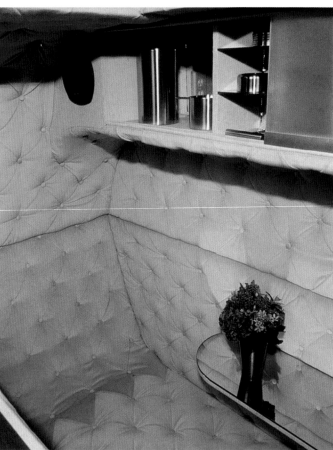

Andrea Zittel, *A-Z Escape Vehicle Owned and Customized by Robert Shiffler*, 1996, shell: steel, insulation, wood, glass; interior: flotation tank, water

Andrea Zittel, *A-Z Escape Vehicle Owned and Customized by Andrea Rosen*, 1996, shell: steel, insulation, wood, glass; interior: velvet, glass, objects

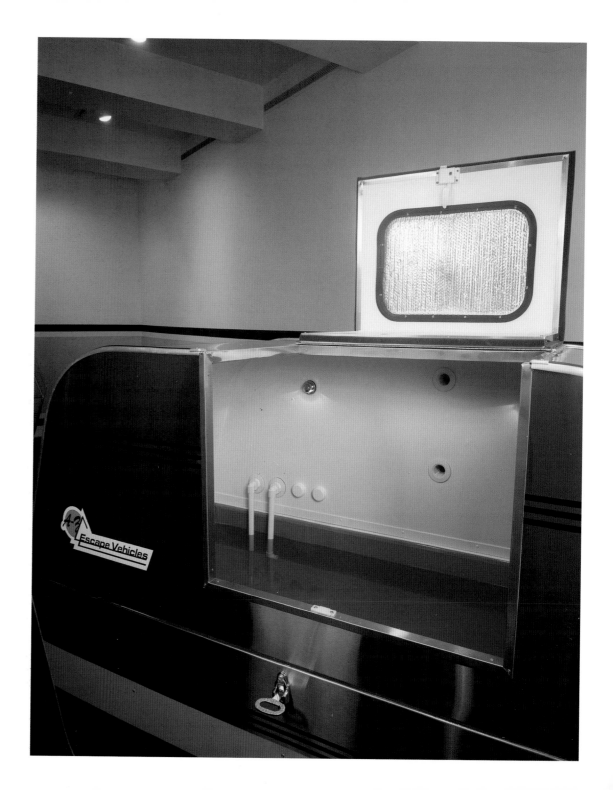

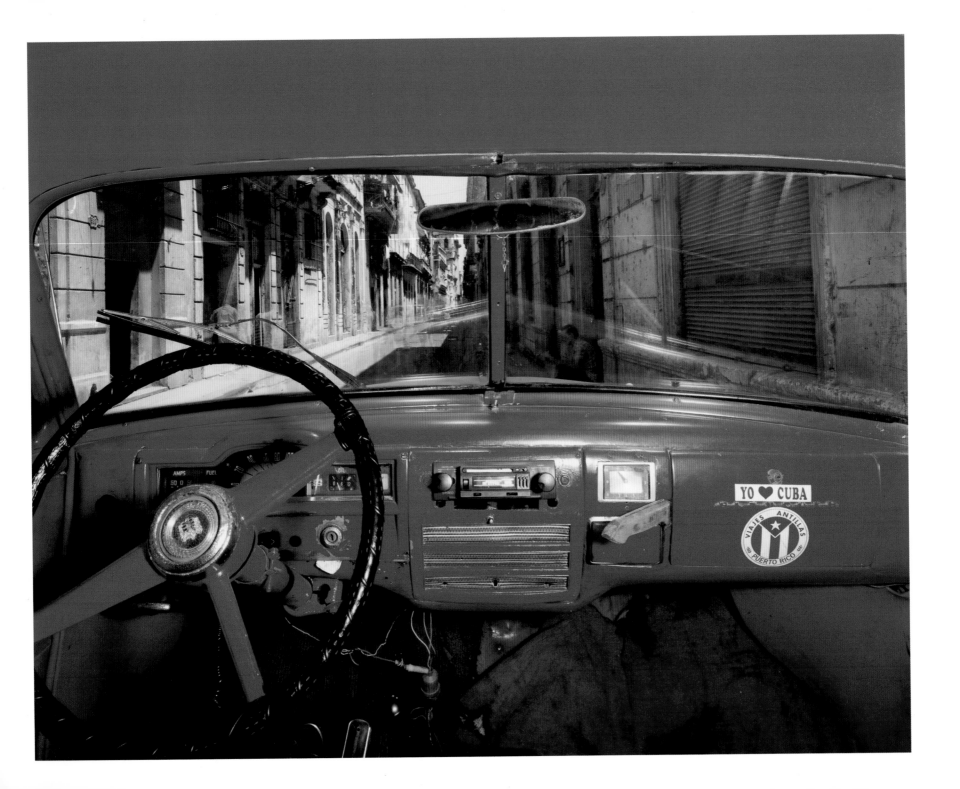

WINDSHIELD

LUCY FLINT-GOHLKE

Alex Harris, *May 28, 1998, Orestes Aracinana Suarez's 1952 Chevy*, color print

Left. Alex Harris, *May 23, 1998, Jorge Alberto Roja's 1951 Plymouth, View of Haban Vieja Street (calle Sol y Cuba) Facing North*, 1998, color print

Following pages. Blake Rayne, *Autumn Drive: Part I* and *Part II*, 1998, oil on canvas, acrylic on wood

A photographer shoots inside a car. The camera she holds has an aperture that opens and closes to allow for the controlled passage of light and the information it contains onto a segment of sensitized film. She herself is an organism forming visual impressions based on data passing through the pupils of her eyes, which, like the camera shutter, dilate and contract to adjust the quantity of light that enters. The car in which she sits is a complex machine whose activity is dependent on the operator's interpretation of visual data ushered in through transparent panes of glass. The photographer, camera and car are intimately linked in parallel actions.

Cars and cameras both entered mass production at the turn of the 20th century, and have been essential and often associated elements in American life ever since. Both are closely connected with personal identity, family mythology, and national ideals of freedom, opportunity and self-expression. Any number of the luminaries in the canonical history of photography—Alfred Stieglitz, Edward Steichen, Dorothea Lange—trained their cameras on human subjects within the car interior, drawn to the intimate architectural scale it provides for the delineation of personality. This preoccupation has continued unabated, with new possibilities arising as technology evolves.

In Alex Harris's *May 23, 1998, Jorge Alberto Rojas's 1951 Plymouth, View of Haban Vieja Street (calle Sol y Cuba) Facing North*, the windshield frames a panorama lit by a vigorous midafternoon sun. On the inside, the scene is equally bright. Unbeknownst to the viewer, the photographer has made ten or fifteen separate exposures as he moves a light across the inside of the car in order to illuminate the interior space evenly. This active "painting" with light, along with a depth of field that renders dashboard and street with equal sharpness, produces an image in which the customary relationship between interior and exterior, personal and public, sheltered and exposed, is overturned. Contemporary Havana, redolent with history, becomes part of the same tableau as the old American car interior with its patriotic emblem,

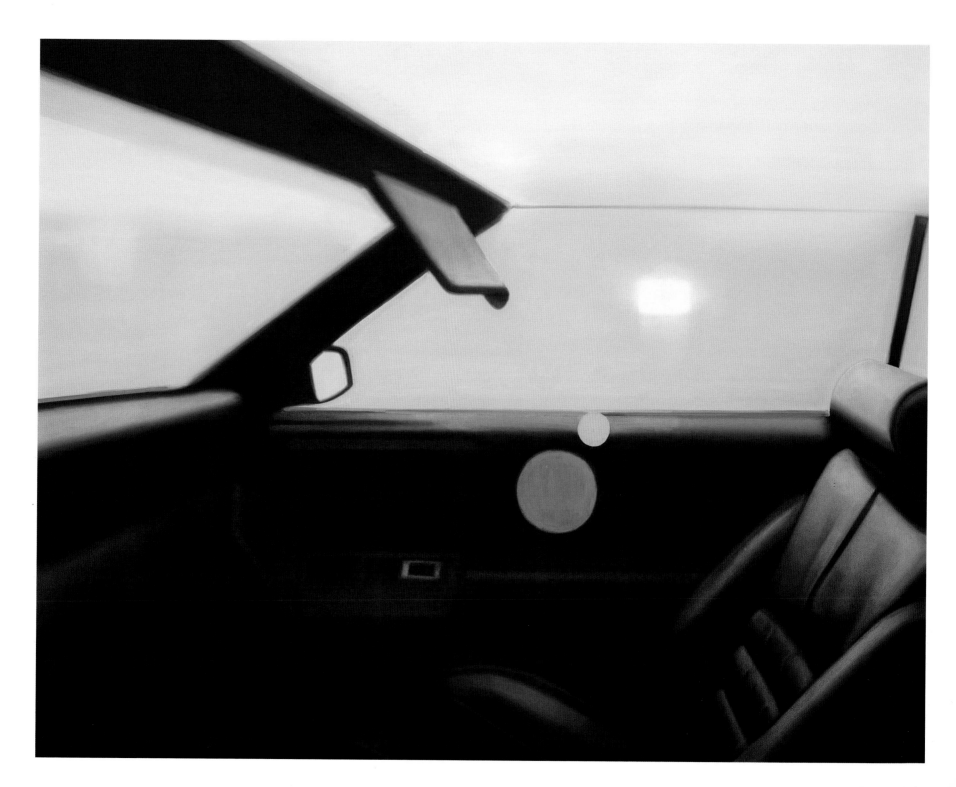

mysterious knife handle and capitalist origin. While the specificity of facts detailed in Harris's title suggests faith in the documentary purposes of photography, the visual impression produced by the artist's manipulations derails it. Printed life-size the image becomes even more surreal, as the ghosts of figures walk down the street, glimpsed repeatedly in 1/15-second exposures.

When light from a camera's flash directly hits a pane of glass it bounces back like a sunburst. Reflected sunlight may produce, at the same time, a flare in the lens of the camera, a perfect and chromatically pure disc which gets recorded on the photographic emulsion and appears on the film. In Blake Rayne's painting *Autumn Drive: Part II*, this accidental effect is reproduced rather than "corrected": the painter is scrupulous to show everything in his visual field, suggesting that the artist's way of seeing is both disciplined and uncorrupted. At the same time, he gives a gestural flourish to the painting of these episodes of photographic effect, showing how deceptive perception is and how easily the artist distorts it.

An analogue of the photographic process, the mirror can compound and confuse our understanding of the path of light. When a car mirror is photographed within a landscape it functions like a collage fragment, producing a paradoxical double view of forward and back, positive and reverse, future and past. In a still from Sophie Calle and Gregory Shephard's video *Double Blind*, the cubistic overlays of planes evoke more the fragmentation of memory than the supposed coherence of photography. Like the cars' other distortions of the external world—blurring, cropping, framing—the double view the mirror creates is so familiar as to go unremarked. The cognitive correction happens automatically and the phenomenon becomes all but invisible until someone, like an artist, untrains our perception and alerts us to the peculiarities of visual experience.

Pictorial conventions guide us in seeking meaning, and lighting is frequently an essential cue. In Nan Goldin's *Kathleen in the Taxi to Greer's*

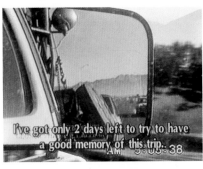

Sophie Calle and Gregory Shephard,
Double Blind, 1992

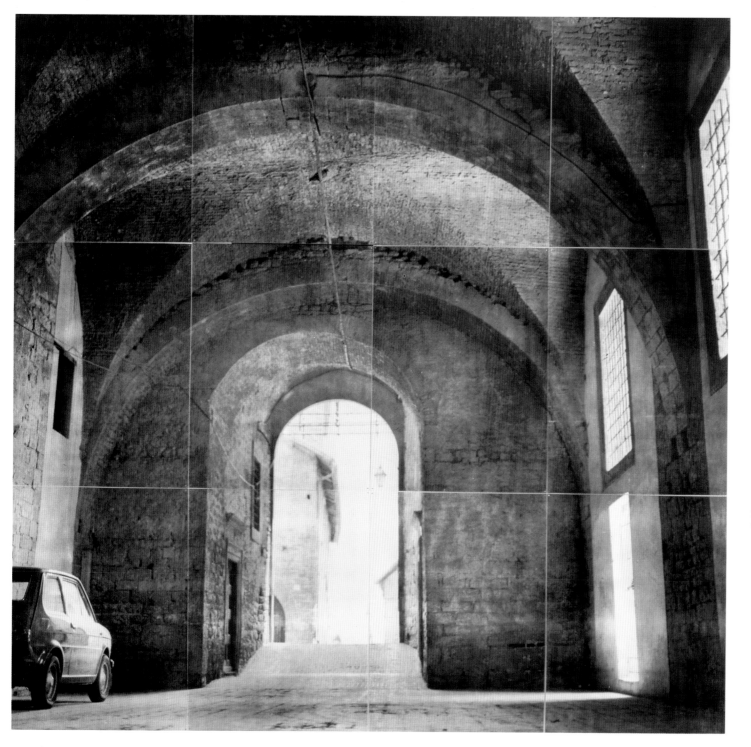

I could hear the voices of a couple arguing in the distance. It sounds as though they have entered the arcade, but only their voices have entered, and linger for a while even after they have passed the opening and continue on their way. The intensity of their voices indicates an argument, but I am not really concentrating on them completely. It seems as though even if they had walked through they would not have noticed the presence of anyone, let alone anyone having sex. It is around noon time, other than that and you can hear a pin drop in this echo chamber. An open car door, the perfect hour, perfect opportunity. We get into the car, which becomes a small cramped room within a larger room.

Lorna Simpson, *The Car*, 1995, serigraph on 12 felt panes with 1 felt text panel, edition of 3, Courtesy Sean Kelly Gallery, New York

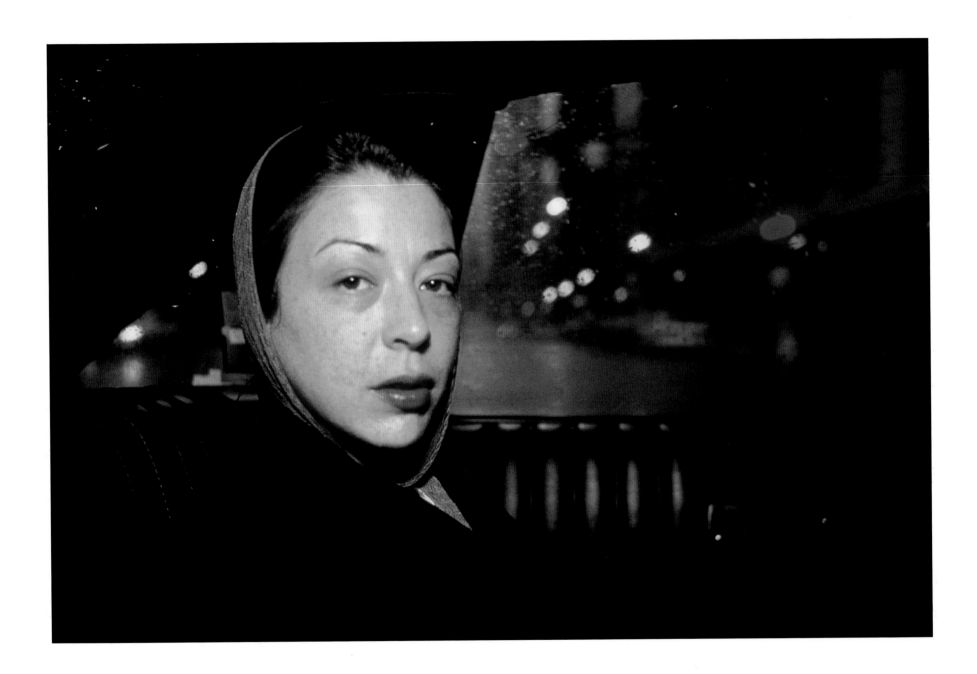

Funeral, Chicago, the heart shape of the protagonist's face is isolated and exquisitely lit, functioning as if it were the light source itself. Her face and the title of the piece prompt us to think about grief, death, solitude, the metaphor of travel, and the place of ritual in contemporary life. But we may also notice that the red traffic lights outside form an arrow pointing at her face, elegantly enhancing the redness of her eyes and lips. Conscious of the artifice of the picture and the skill with which the photographer handles her flash, we may question her motives — is she a long-time friend of the subject who is memorializing the feelings they both share at the loss of a third friend or an exhibitionist who aestheticizes reflections of her own emotional extremism within lush visual landscapes?

Ultimately, as ordinary viewers we may remain uncertain what's being illuminated in these images and what we should think about them. Just as someone could be making love in the back seat of a car, unseen, there might be something going on in these works of art that we don't know about or "get." At first look, Lorna Simpson's *The Car* appears to be about the quality of an uninhabited space only incidentally occupied by a car. Vast and gray vaulted depths lead to an arched opening that promises egress to a sunlit city. But the accompanying text, like the voice-over in a film, wedges its way into the picture to dramatically redirect its meaning and implicate us in unwilled peeping. Control of the image is reclaimed by the artist — only she knows what she's showing, whether it's the poetic indeterminacy of visual narration or the power of her own sorcery.

In addition to the meanings that derive from the intersection of the artist's insight with the viewer's imagination, the work of art may suggest other meanings that the critic decodes and the historian clarifies. Artists often distrust analysis of their work, knowing how easily words can shade interpretation. In attempting to shed light, commentators run the risk of blinding viewers to their own responses — once you're told what you're seeing, you may find yourself unable to look at it any other way again. The ease with which meaning can be planted goes to the heart of the long problem of photography's supposed status as a passive form of expression. Since it reports fact, its meaning must be self-evident. This view ignores the photographer — the person in the driver's seat, so to speak — who makes the vehicle accelerate, slow down, turn, stop, spin, lurch, light up, warm up, cool down and go to places it has never been before. The journey's ultimate destination and significance remain elusive and interpretable to all.

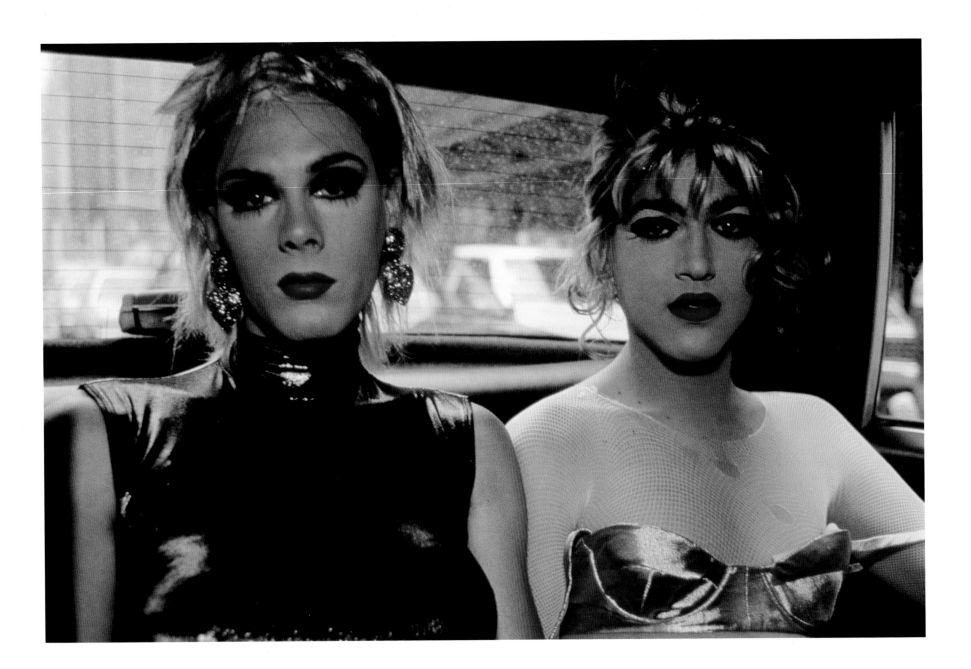

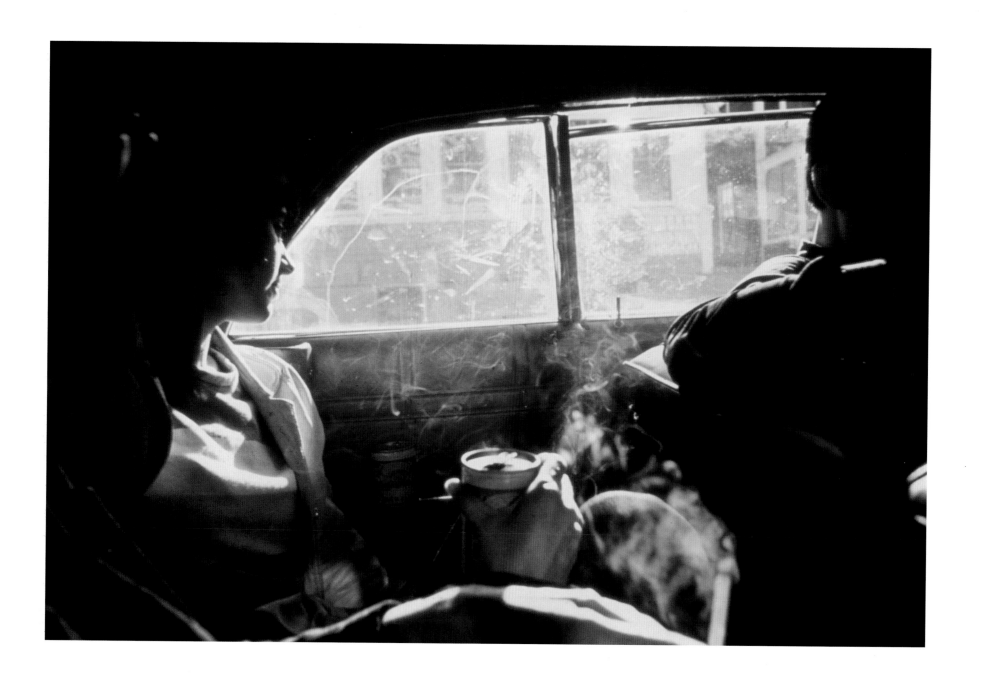

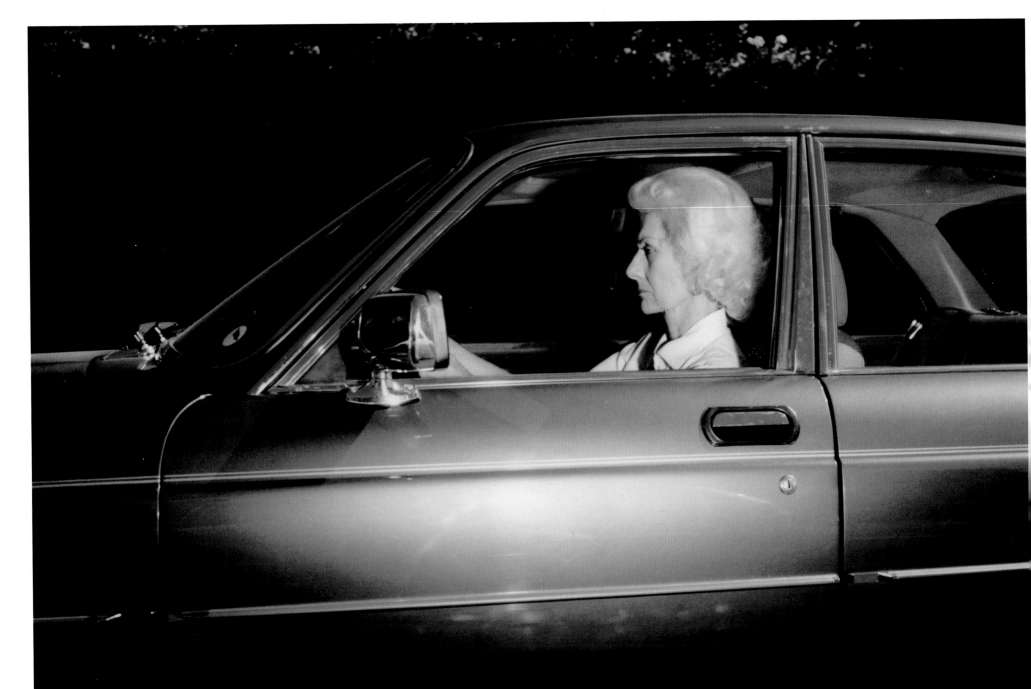

DRIVER

J. ABBOTT MILLER / PHOTOGRAPHY ANDREW BUSH

Zooming by in the next lane, fellow drivers and their passengers become momentary comrades, seemingly *en route* to the same destination. When I was a child, the game of eliciting waves from passing cars and trucks—and even getting drivers to honk their horns—provided diversion on long-distance car trips. But as an adult, this sudden proximity of drivers and passengers is more often an occasion for hostile exchanges: a chance to stare down an aggressive driver, or to refuse looking at someone waiting to give you a dirty look for not getting out of the "fast lane" quickly enough. If the person who suddenly appears in the next lane is a police officer, I might engage in an affected nonchalance, implying that my sudden deceleration was a stylistic decision, or a matter of mood. Car glances, especially those that transpire at stoplights, are related to the social scenario of the elevator, except that no one feels obliged to speak. Andrew Bush's series of *Vector Portraits* document these sidelong glances. Armed with a camera mounted inside of his own car, Bush's mechanical passenger glimpses drivers and passengers in all of their purposeful anonymity. Occasionally, his subjects meet the eye of the camera and smile, but most are unaware of the intrusion.

The *Vector Portraits* exploit the public stage of the car's glass membrane. The tinted windows that shield celebrities and drug dealers are an attempt to fortify this fragile barrier, to make the car more like a room and less like a bubble. My parents told me the reason we could not have the lights on inside the car at night was because the police would assume we were counting money after robbing a bank. It was a provocative thought: light as a signifier of crime, as opposed to the usual "under cover of darkness" scenario. Today the connection between cars and crime is more mundane and less exotic. New terms such as "car-jacking," "drive-by shootings," and "road rage" reveal the collision of automobility and crime. Perhaps this accounts for the undercurrent of danger and paranoia evident in Bush's photographs of what are supposed to be fleeting, and therefore undocumented, moments.

Andrew Bush, *Vector Portraits*, 1989–92, ecktacolor prints

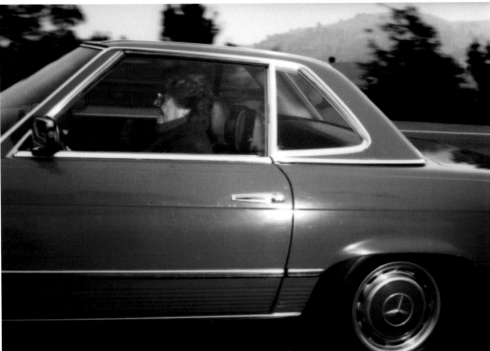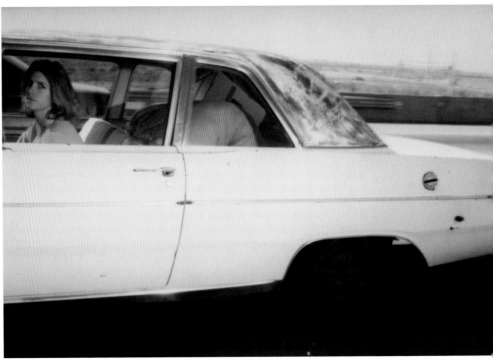

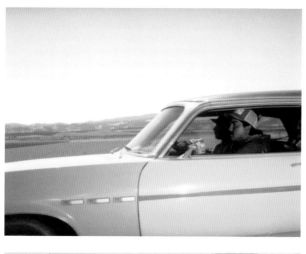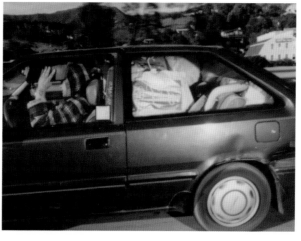

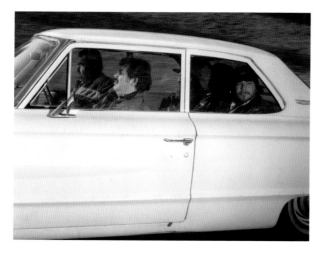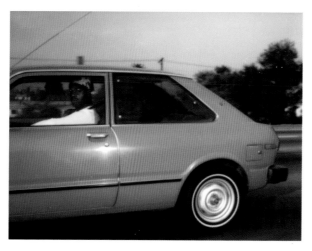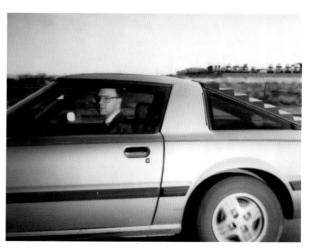

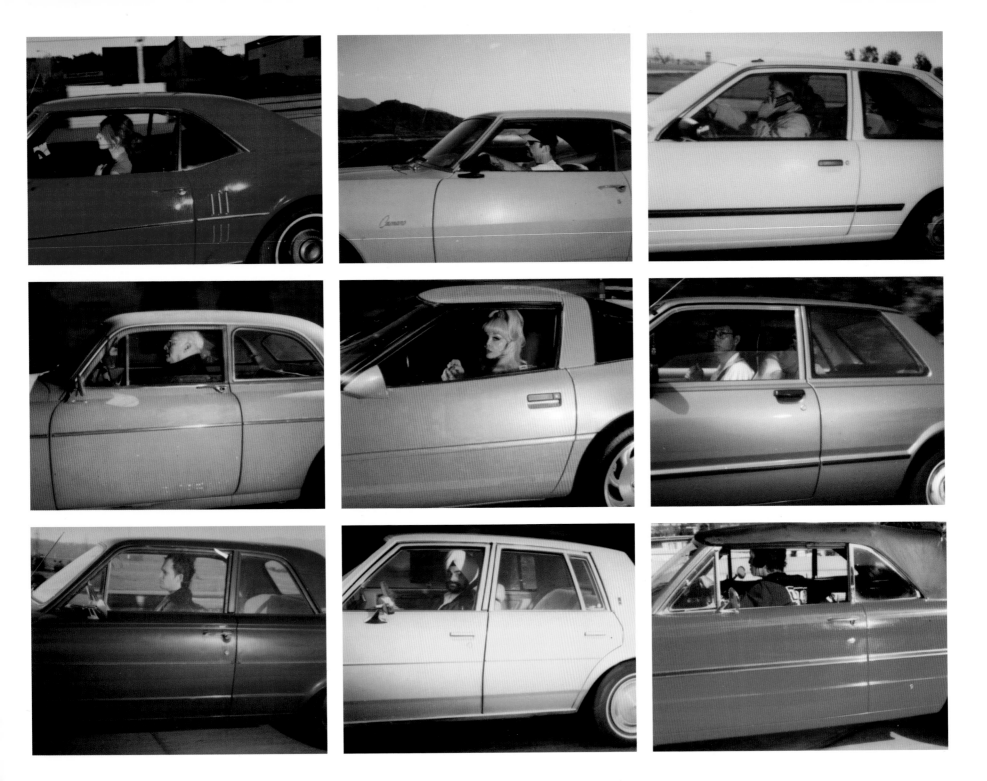

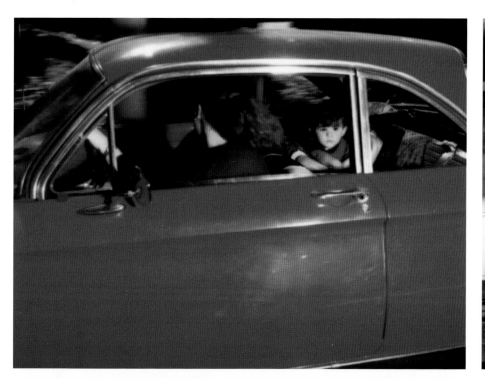

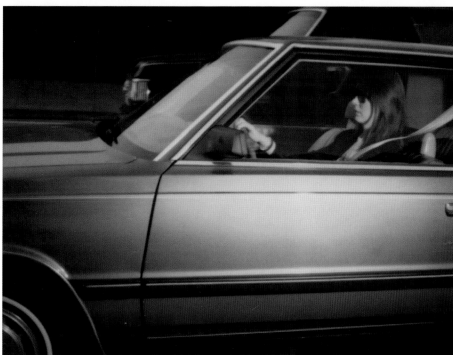
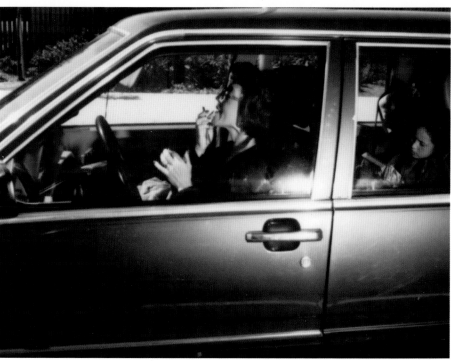

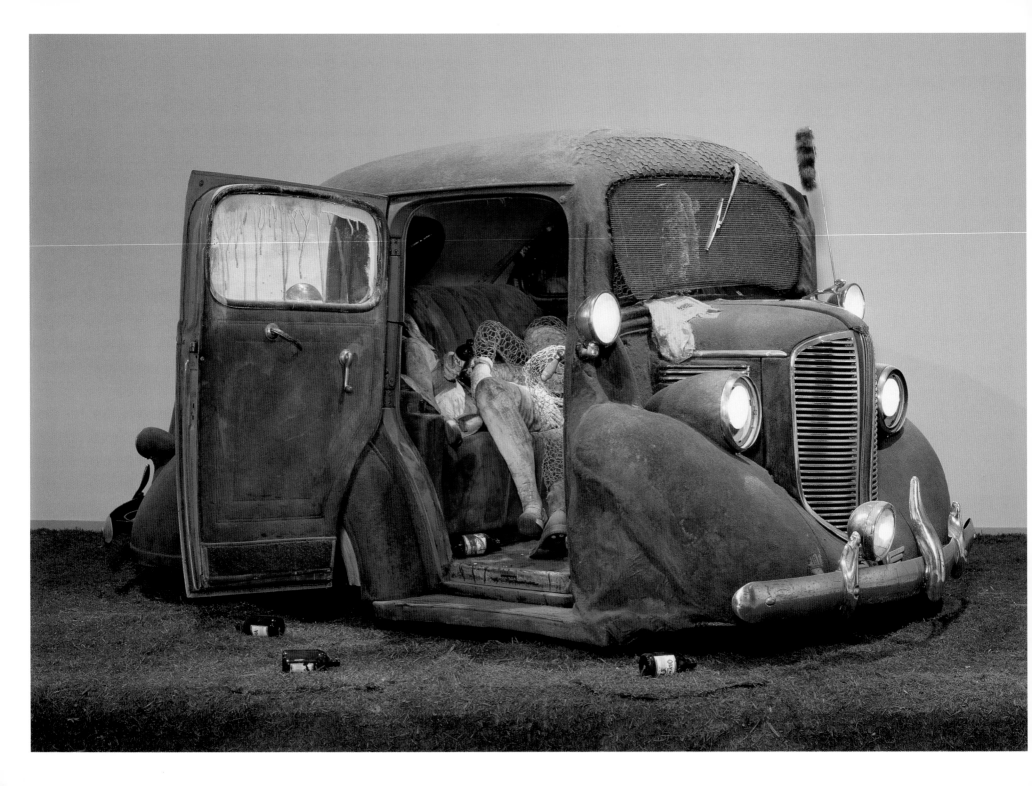

BACK SEAT GREIL MARCUS

Films about America should be composed entirely of long and wide shots,
as music about America already is.
Wim Wenders, "Pan Am Makes the Big Flight," 1969

When you live from the inside of a car, you want to bring the outside in—
nobody who's driving hides in a car that's still moving. The song that's playing
inside the car can make the space smaller, throwing you back on yourself;
it can dissolve the space inside the car altogether, making you at once subject
and, for as long as the momentum of the song lasts, ruler of the world as
it passes by.

The idea only works through the radio. The transformation of automobiles
into home entertainment centers, with cassette players and CD players—
never mind television sets, car phones, or fax machines—is precisely a way
of shutting the outside out, of making sure it can never impinge on the
self-affirmation of the driver as the only person in the world. To be the only
person in the world is not the same as being its subject or its ruler. With
a car radio, you can change the station every split second, but you can't
command the music, can't determine what message the outside world will
send you; you play a long shot. You are subject to the caprice of the radio,
until, if you're lucky, you're suddenly allowed to feel as if the world was
made for your pleasure.

The car doesn't even have to be moving, just—as the "Don't bother
knockin'" bumper stickers on vans used to say—"rockin'." Think of Ed
Kienholz's all-American *Back Seat Dodge '38*, made in 1964, just a few years
after the great 1950s designs for Chevrolets and the creation of the Interstate
Highway System made the glamorous myth of the open road an everyday
fact. *Back Seat Dodge* is a big, ugly, even hideous work, the squashed car
with a smear of what looks like blood on the windshield, a woman's under-
pants stuck to the windshield wiper, beer bottles scattered on the floor,

Edward Kienholz, *Back Seat Dodge '38*, 1964,
paint, fiberglass and flock, 1938 Dodge, chicken
wire, beer bottles, artificial grass, and cast
plaster, Los Angeles County Museum of Art,
Art Museum Council Fund, photograph © 2001
Museum Associates/LACMA, M.81.248a-e

dirt and probably more blood all over the woman in the backseat, the man—aside from his shoes and hands, he is made out of chicken wire—fingering her crotch, and one head—or one thing where the heads would be—for both. It's hilarious to read the copy in the catalogue to the 1996 Whitney Museum of American Art's *Kienholz: A Retrospective*: noting that when first exhibited in 1966 in Los Angeles, some county supervisors condemned the work and wanted it removed from the county museum, Rosetta Brooks writes that "Today it is difficult to understand why the work caused such outrage. At its simplest reading it can be described as a young couple making out in the back of a car...."

When this particular work provokes no outrage, either those looking at it have shut down their ability to react, or the work isn't getting across—it's not making the noise that's in it. There's nothing young about the rotting figures splayed on the seat. They aren't necessarily, and certainly not completely, a couple, which is to say they're not exactly human—and the figures, whoever they are, are not making out. They're fucking—and something about the act itself, or the desire for it, is removing their humanity like skin, layer by layer, until, watching, the viewer feels unclean—not because the work has made one into a voyeur, but because very nearly anyone watching has been in that backseat, maybe going that far, maybe, the piece says, lucky enough to have stopped. As Chuck Berry once said when asked why he wrote so many songs about cars: "Because everybody has one."

Even though the viewer stands outside of it, the work—like Kienholz's dead-end rooming houses and hotel rooms—is claustrophobic. But the car begs the question. Yes, they're fucking, yes, it's more skin-crawlingly creepy than the bad-sex scenes in, say, the 1989 *Last Exit to Brooklyn* or the 1997 *Going All the Way*, where even a naked Rose McGowan is on the verge of throwing up: but what's on the radio?

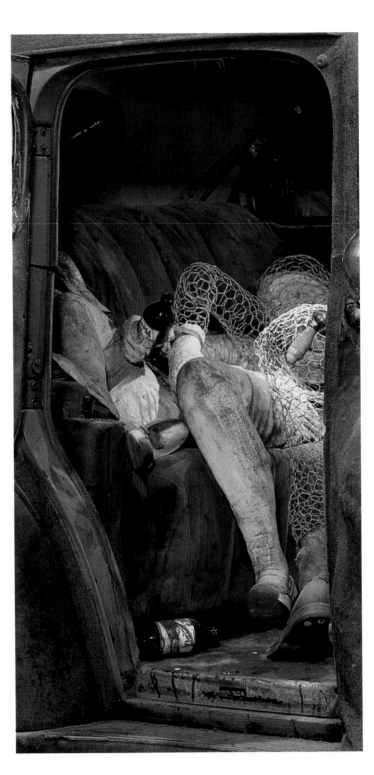

Edward Kienholz, interior detail of *Back Seat Dodge '38*, 1964

With that question, the work instantly opens up; any road, or none, is open to it. Now it's no longer the artist's intention that's at issue. Suppose Ed Kienholz had put a radio in the car, hooked it up to an unseen power source, set it on a good station, and let it play: *Back Seat Dodge* would change every three minutes. So now the radio's on, and it's—Barry White, with his unforgettably oleaginous number-one hit "Can't Get Enough of Your Love, Babe" from 1974! The backseat is really dripping now—but then it's Ja Rule with his twenty-first-century Barry White equivalent "Put It On Me," which if anything is more gross than anything Kienholz came up with, and the writhing figures now even less human than before. But the radio is more perverse than the artist: now it's Peggy Lee's 1969 "Is That All There Is," written by Jerry Leiber and Mike Stoller of 1950s Coasters fame as an art song, the record arranged by Oscar-night perennnial Randy Newman, and if the Dodge was metaphorically rockin', now it stops cold. From its words to its beyond-the-grave pace to Miss Lee's seen-it-all delivery, "Is That All There Is" is all irony, and you can't make irony out of slime.

And then the piece, or the viewer, or the creatures in the backseat get lucky. A huge, stop-time beat locks in, and it's the Ronettes, in 1963, with "Be My Baby."

This is the sound—producer Phil Spector's sound, with his Philles label's motto, "Tomorrow's Sound Today," riding the beat—that made Brian Wilson of the Beach Boys, who as Kienholz was contriving *Back Seat Dodge* was writing the best car songs of the era, from "Shut Down" to "Fun, Fun, Fun" to "I Get Around," want to kill himself in envy. With this sound the car isn't just rockin', it's flying. Suddenly the figures in the backseat are suffused with affection, for each other, even for whoever's looking at them; now your flesh stirs with theirs, and you want to be in that backseat. A sense of the glorious explodes the cramped and dingy interior, puts a glow in the woman's legs you can feel through the grime—you can almost see her kick. The song fills the car with possibility—and that's the long shot.

This is the utopian moment—"Be My Baby" rewriting *Back Seat Dodge '38* in an instant. Any driver's life is filled with them, those moments where the automobile is no more a barrier between you and the terrain you're covering than your own body would be—when, really, it can be less that the music takes the driver out of the car than that the music brings the road into the automobile. Of course, you could always be listening to NPR.

You could be listening to the avuncular Bob Edwards, say, on "Morning Edition," or the orderly Linda Wertheimer and Robert Siegel on "All Things Considered," and then you might as well be in your living room. No surprise is permitted entry here: no bad weather, no accidents, not even a skid in the rain. The format flatters the listener that he or she is interested in those things that merit interest, concerned with those matters that merit concern. Should Ronnie Spector of the Ronettes be mentioned it would be because she had written a book; should Phil Spector be mentioned it would be because he had died; should the Beach Boys' "Fun, Fun, Fun" be played it would be to orchestrate a museum exhibition on the place of the automobile in American life. Every shot would take the viewer through a door, and confine the viewer in a room the purpose of which is to foreclose certain avenues of escape, which is to say thoughts or emotions: to limit response.

So it is more than possible to climb into an automobile and then traverse any landscape the nation might provide and find oneself utterly removed from it. The interior of the car then becomes not the whole of the machine but, subsuming the road, the whole of the country, or whatever frame of reference it is in which one travels, whether crossing from Arkansas into Texas or from the bathroom to the bedroom. There is no need for any long shot. You've seen it all before—or, perhaps more truly, it's been seen for you.

So change the station, or get out of the car.

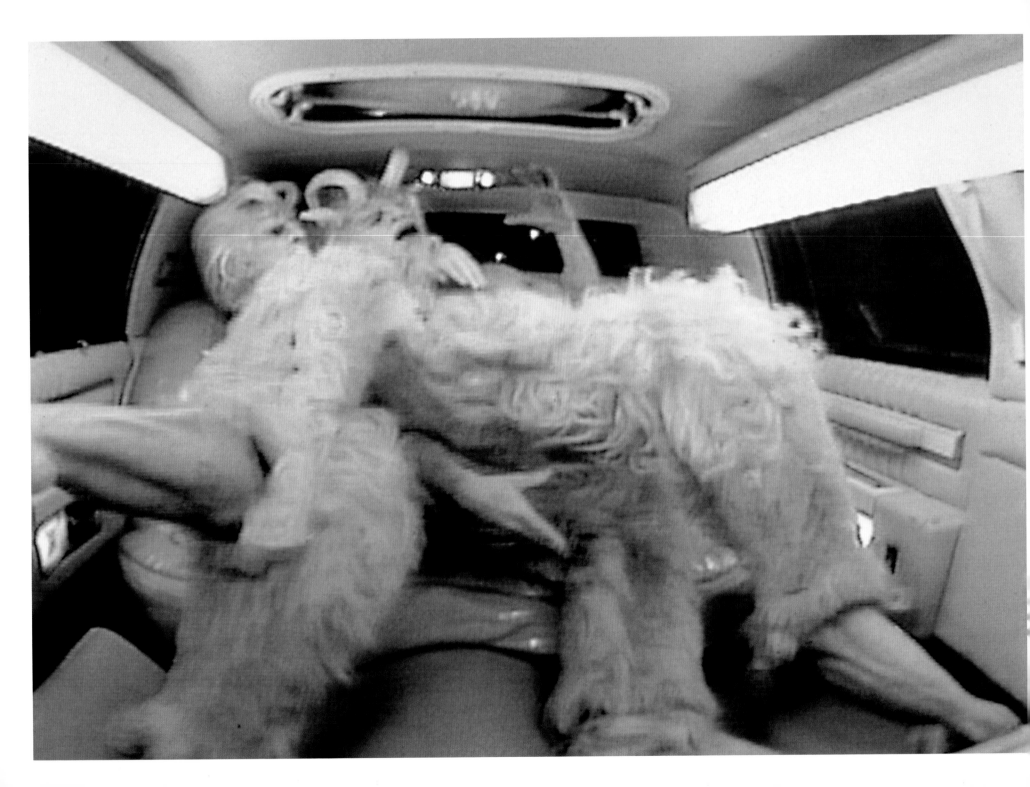

ENGINE DAVID FRANKEL

Above and Left. Matthew Barney, *Drawing Restraint 7*, 1993. Photographs courtesy Barbara Gladstone Gallery

Matthew Barney's engines don't go anywhere. This is the first thing you notice about them: maybe they move, like the cruising limo in *Drawing Restraint 7* (1993), or even speed, like the racing bikes in *Cremaster 4* (1994), but all of these vehicles are on a circuit, a loop. The limo is touring Manhattan by running around its edges, passing over and back again through all the bridges and tunnels that lead into the city, but also out of it — and the car never stops on the island. The bikes and their sidecars too are engaged in a road race, a journey without destination. Races need not be circular, of course, but all of them love movement — not movement to get somewhere new but movement itself, an essence of movement, the more of it, condensed into the least time, the better. And this particular race, in any case, is once again on an island, the Isle of Man, which, unlike Manhattan, is without on- and off-ramps: go as far as you like, you can only run in rings. To speed outrageously only to end where you began — it is a contrary motif for an artist fascinated by change.

Barney's sculptures, videos, and films have an extraordinary visual lushness. Whether set in a Budapest bathhouse, an American football stadium, or a blimp, his *Cremaster* movies — a series of five, completed in 1999 — orchestrate rich arrays of surfaces, fabrics, substances. Tessellated planes of tile and mirror contrast with oozing corporeal gels, depths of flowers and feathers with slick leathers, Busby Berkeley satins, and that white, self-lubricating plastic used in medical equipment. A taste for clothing the body in elaborate costumes shades into the transformation of the body itself, which may appear horned, or furred, or blossoming into layers of colored tissue like some fabulous underwater coral.

Underpinning these spectacles, and the stories accompanying them, is a fantastical self-devised mythology, a symbol system providing explanations for Barney's images, forms, and materials — though not necessarily to the viewer. But figures and themes recur, allowing meanings to knit together.

Sexual imagery is a constant, though it is often baroque, provoking giggles and squirms. The familiar male/female geography is nothing Barney ever takes for granted, and this part of his thinking also manifests in the recurring presence of the escape artist Houdini, whose work seems to signify to Barney that artmaking is a place where the limitations of the body are overcome. Perhaps the racing bikes and sidecars in *Cremaster 4* fit in here as well: hard, mobile shells, they fit like a glove, fusing a team of two into a single organism and empowering them beyond their own capabilities. Exoskeletons encasing the body's soft tissue, these are vehicles without interiors, flush with the flesh that they extend and amplify. Barney's transformations of the body are often more literal, but this one is available with existing technology.

A car is always a box or sheath for its inhabitants, but usually it allows them a little breathing room. In *Drawing Restraint 7*, the interior of the limo becomes a whole theater, as ripe for action as the featureless space — perhaps a stage or rehearsal room, but in any case a place with no clear boundary — in which the characters sometimes prance. In fact that limitless space seems a less surprising arena for these particular figures, who are satyrs, half goat, half man, the lustful spirits of classical Greek myth. In an impressive piece of performance abracadabra, Barney gives them not only curling beards, hair, and horns but amazing white-furred legs with full-length, forward-pointing shins below the ankle, ending in cloven hoofs. A third, taller protagonist also has budlike horns, but a hairless body and a long string-of-sausage-like tail. All of these figures, though preponderantly male, turn amorphous at the crotch, as though their gender were an unsettled issue.

For such creatures to travel by limo, of course, is the surreal anachronism that gives the work its punch — as if real-looking satyrs needed punch. The inside of the car is cushioned in boy baby-blue. Otherwise, though, it's anonymous, even cold. A row of bright fluorescent rims the ceiling. The seats are covered in plastic, the way people sometimes cover the chairs in an unused formal sitting room, as if anticipating the unlikely guest who will put his feet on the furniture — but the plastic does turn in handy when the feet are hooves. And also when hoofed guests wrestle. For the action in this supposedly luxurious vehicle is a physical fight, a goat-boys' tussle. Although we sometimes see one of them alone, apparently enjoying his ride, more often we see a pair locked in struggle and grappling for advantage on the car's backseat. The backseat of a car, of course, is a classic erotic site in the annals of adolescence. That might explain the lack of open animosity in the satyrs' combat, and the fact that this ballet of straining torsos has no apparent cause, no sparking grudge. Nor does it have any obvious goal, and in fact it is unclear what would justify a claim of victory. Perhaps this wrestling match is an image of Eros and Thanatos, of the unappeasable desire that is life's energy, because it is unsatisfiable — or, if satisfied, is only renewed.

That might also help to explain the car's only unusual features: the porosity of front and rear, and the weird moon roof. Unlike any car I have ever been in, the satyrs' limo lets them squeeze through the crack between the front seat and its back, to emerge on the passenger side. The skylight too is odd: during the drive, it bubbles, clouds, and swells, like some peculiar chrysalis. Add to this the fact that the car's route is through tunnels and over bridges, visible occasionally outside the windows and windshield. All these are images of birth, of passage, of psychic and physical transition. But transition to what? The car never gets where it's going, arriving only to leave. And change without end, like the erotic struggle of the satyrs, is less like change toward a goal and more like the process of life.

A car that isn't going anywhere reappears in *Cremaster 2* (1999), but this time it's literally motionless. A Ford Mustang, it belongs to Gary Gilmore, who, in 1976 in Utah, robbed and shot a gas station attendant, Max Jensen, and for this and another murder was eventually condemned to death and executed by firing squad. Gilmore is the central character in *Cremaster 2*.

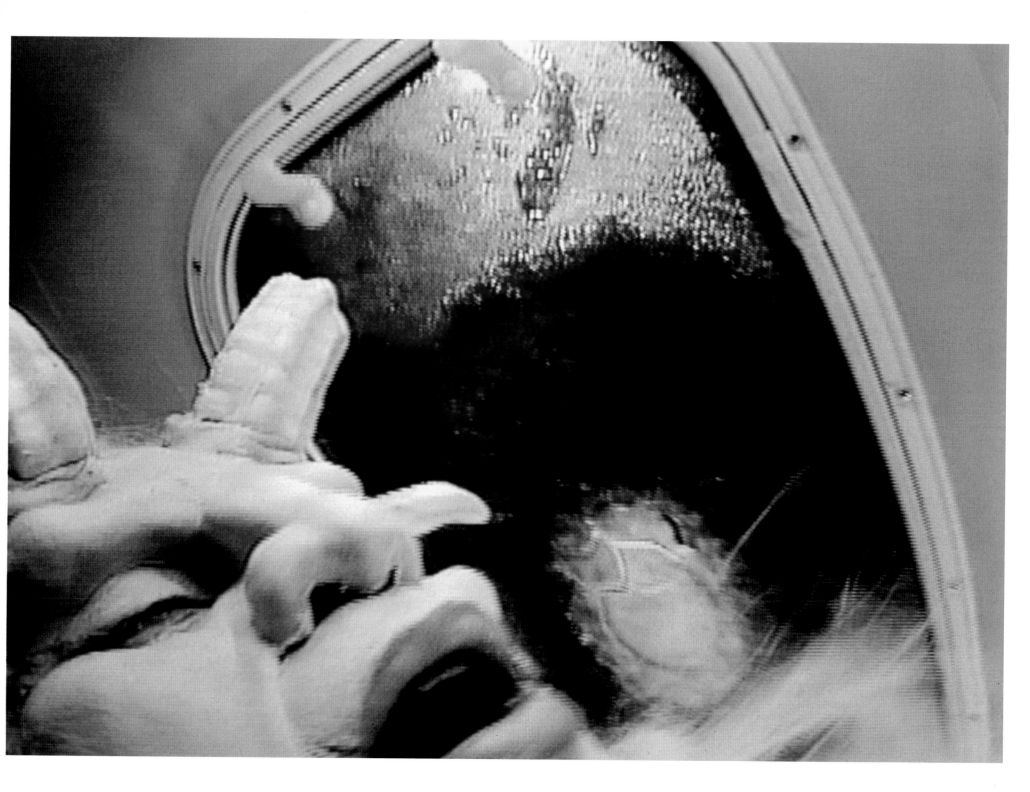

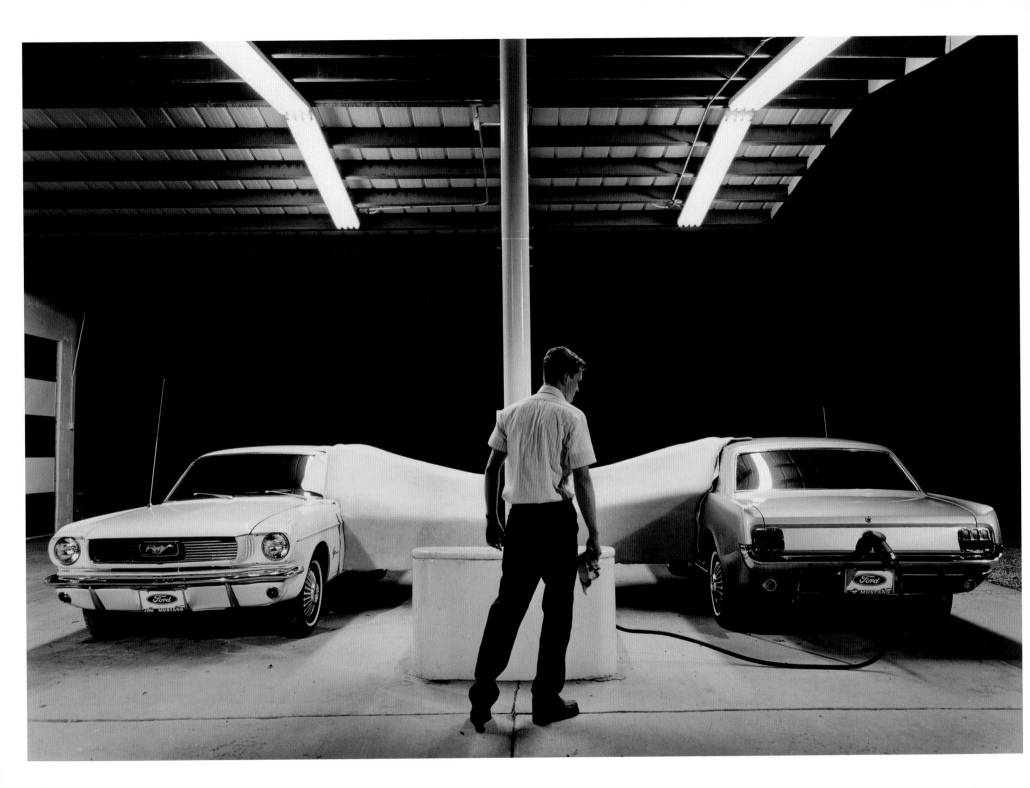

Matthew Barney, *Cremaster 2: The Drone's Cell*, 1999

Left. Matthew Barney, *Cremaster 2: The Ballad of Max Jensen*, 1999

Predictably, and properly so, the film is altogether more somber in tone than the antic *Drawing Restraint 7*. Which is not to say that it lacks Barney's characteristic visual flights. It begins with the scene of Gilmore's conception, which, as Barney imagines it, makes you think that the startled virgins in all those medieval Annunciations had things easy. (Let's just say it is a quasi-medical procedure involving bees.) Gilmore's execution takes place as a kind of glacial rodeo, in a stadium of brilliant white salt, and is followed by an episode in what may be the afterlife, visualized as a rather formal dance hall where a couple dances the two-step around a saddle completely covered in mirrored glass. The heart of the film, though, is the scene in the car, which Barney shows parked in the gas station where Gilmore shot Jensen.

When Gilmore pulled into the gas station he was actually driving a white truck, but he had earlier owned a Mustang. His girlfriend Nicole Baker had also owned a Mustang—a coincidence, but a coincidence they liked. Perhaps Barney liked it too, or perhaps he liked the word "mustang," a word with a history in the American West, whose imagery fills *Cremaster 2*. In any case he shows Gilmore's car as a Mustang. In another departure from history, he shows Baker's car as well as Gilmore's parked in the gas station, coldly lit in the black dark. Aligned on opposite sides of the gas-pump island, the two cars are connected by a kind of wasp-waisted tunnel—again one thinks of a passage, a transition, a birth—and just as bees attended Gilmore's conception, this tunnel, viewed from the driver's seat, summons the honeycomb: it is hexagonal in overall shape, and a hexagon-patterned texture mottles its surface. It's as if the two cars were fusing together through some process of crystal formation, some apiarian process of the hive. Indeed the hexagonal tunnel seems to have spread into the interior of Gilmore's car, making it lowering, tight, and claustrophobic. It is a confusing space, seeming to mirror or replicate itself as cells do. The beehive is a place of metamorphosis, of genesis, of the conversion of one form of energy into

another—yet in the Mustang its geometry turns rigid. The ceiling is too low for Gilmore to sit up straight; he lies on the front seats, fiddling with a thread in the blue-gray plastic upholstery, pulling cotton-candy-like gunk out of the ceiling. Eventually he makes the thread and the gunk into a kind of barrier in the tunnel to the other car. He is waiting to make up his mind.

A car that won't move, deprived of its function of motion, becomes all interior, all inner space. Barney has shown this car as a sculptural installation, *The Cabinet of Gary Gilmore and Nicole Baker*, a form in which it doesn't even have an engine. And although in *Cremaster 2* we see Jensen gas up the car, filling it with latent power, the crystalline growth overtaking it has surely immobilized it. Asked to name a favorite movie a while ago, Barney chose *Evil Dead II*, a cabin-in-the-woods horror film: "That would be very influential to me in the sense that the evil lives in the architecture rather than the person. Even if there is some antagonist circumnavigating the cabin, it's the cabin which is still the vessel that holds the psychology." And so it is with Gilmore's Mustang, a cabin for the mind of a man who kills. All Barney's cars promise change, movement, metamorphosis, but constant change is itself a kind of stasis. Whether driving in circles or standing still, you wind up both different and in the same place where you began.

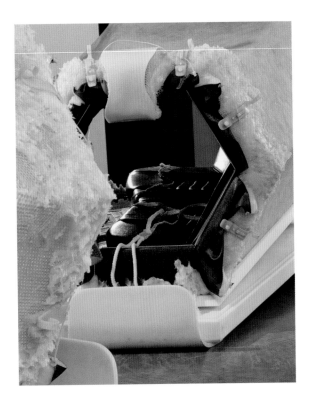

Above and Right. Matthew Barney, *The Cabinet of Gary Gilmore and Nicole Baker*, 1999–2000. Nylon, polycarbonate honeycomb, beeswax, microcrystalline wax, petroleum jelly, polyester, vinyl, carpet, chrome, acrylic, prosthetic plastic, salt, epoxy resin, and sterling silver

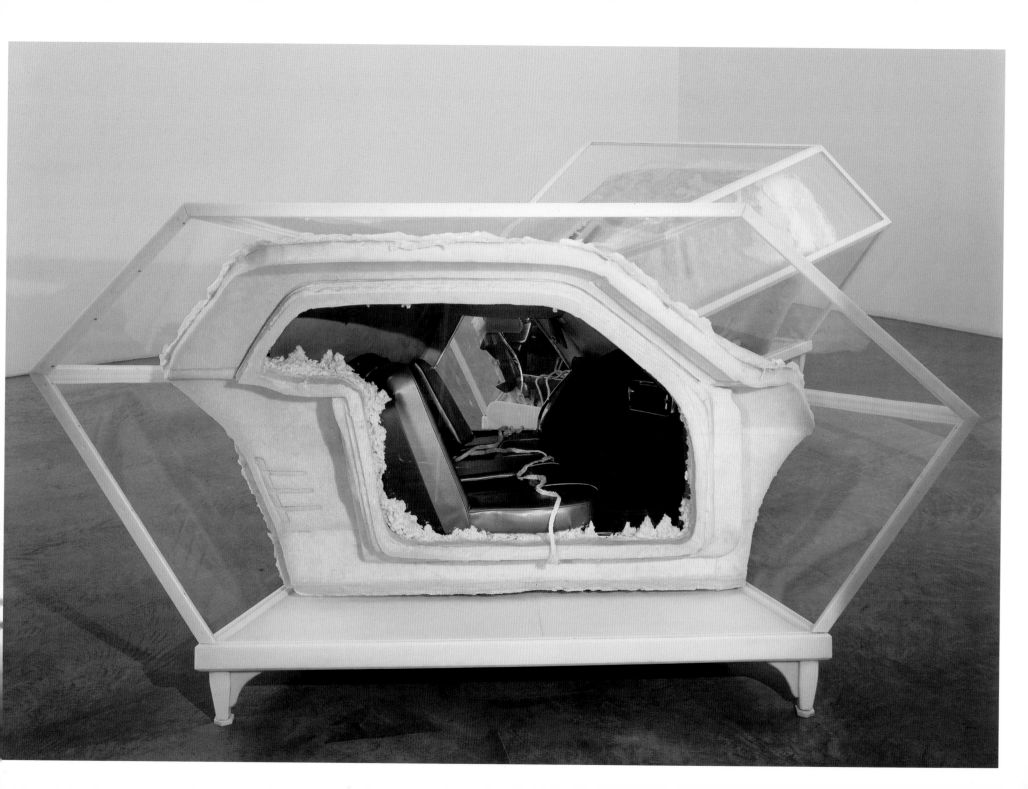

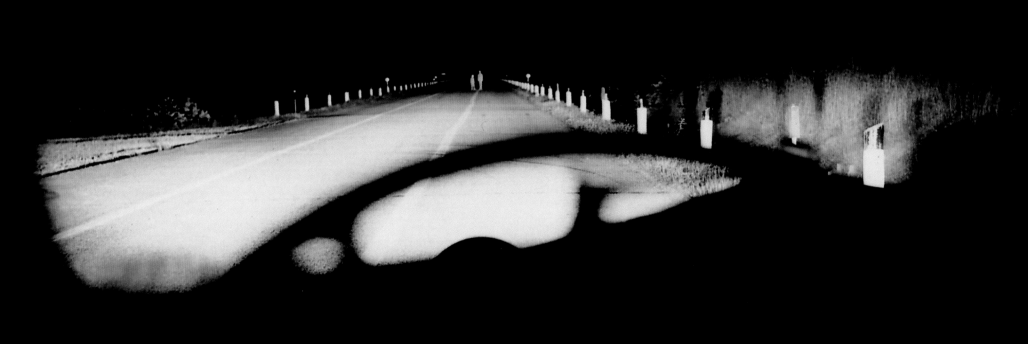

EVIL
PAUL ARTHUR

The age demanded an image of its accelerated grimace...
Ezra Pound

It would be completely understandable, if no less warped, if someone well-versed in pop culture but vague on historical causality imagined that automobiles were originally invented as technical devices for the filming of Hollywood action movies. The political theorist Antonio Gramsci claimed that "Automobile culture is coterminus with Americanism." It is equally true that the American car is coterminus with dramatic and institutional economies of the Hollywood industry. Movies and cars appeared almost simultaneously at the front end of the 20th century; their fates as commodities, and as ciphers for the projection of symbolic meaning, have been entwined ever since. Among a host of obvious symmetries, the assembly line system of manufacture introduced by Henry Ford in 1914 was adopted by juggernaut studios of the thirties as the dominant method for creating motion picture "product." So ubiquitous is the presence of cars in American cinema, both on and behind the screen, that the two industries might seem to have conspired in the fabrication of endless public enticements—Detroit (and Madison Avenue) borrowing visual idioms from action movies which in turn fuel consumer passions through an ethos of "crash consciousness."

Forty years before our current obsession with big-budget vehicular mayhem, at least a decade in advance of the rebellious countercultural energies flaunted in sixties' road movies, film noir was exposing the morbid underside of automobility as part of its sour resistance to Cold War platitudes of social mobility, domestic security, and legal authority. Noir has gained a fashionable, somewhat overblown reputation as narrative repository for unprecedented, erotically charged gender hostilities unleashed in the criminal pursuit of money and power. But of equal significance to the battered portrayal of romantic love is a relentless, perverse treatment of the iconogra-

Wallace Kirkland, 1939, looking out of a car's windshield at light cast by sealed headlights.
Photo courtesy Wallace Kirkland/TimePix, NY

phy of postwar middle-class life: telephones, furniture, corporate buildings, and especially cars. Despite the intense claustrophobia that engulfs film noir's nightmarish industrial cities, so much story time is spent in and around cars that they could be construed as urban road movies. If recent demolition derbies like *Speed* or *Die Hard With a Vengeance* inscribe the automotive image as a buffed piece of soulless machinery—fully commensurate with the box-office calculus of their designs—then noir infuses the family sedan or workaday coupe with a version of Freud's dread of the *unheimlich*, the weirdly familiar, that is usually reserved for horror or science-fiction genres.

For starters, cars are often depicted as extensions of the human body, their rounded roof lines and fenders evincing biomorphic visual rhymes with a character's fedora or boxy suit; *Touch of Evil* is particularly adept at staging this dialogue between vehicle and persona. In the same vein, automobiles also appear as surrogate bodies enacting through motorized movement the (almost exclusively male) protagonists' unhealthy mixture of stolidity, violence, and entropic confusion. The opening of *Double Indemnity*, a seminal noir, neatly encapsulates this eerie exchange of metal and flesh: an out-of-control coupe, driven by a mortally wounded killer, careens along deserted streets like a flailing body. As Marshall McLuhan would later contend: "The car has become the carapace, the protective and aggressive shell, of urban and suburban man." The frequent locus of corporeal metaphors, cars emerged on the screen as a species of mobile architecture. Denied the comforts of domestic space, the transgressive noir hero is "at home" behind the wheel, but perilously so: car interiors are a transient refuge from outside threat that nonetheless remains permeable to observation (or to aggression launched through an open window or from the backseat). Bristling with contradictions, cars are rendered as at once open and closed, transparent and opaque, private and public, instruments of escape and entrapment, sex and death.

As envisioned by master cinematographers such as John Alton or Russell Metty, the noir car is probably closer in expression to the still compositions of Ralph Steiner, Paul Strand, or Walker Evans than it is to the blunt functionality of vehicles in thirties' gangster films. In both structure and social connotation, it is the perfect object to facilitate the hero's fall into a criminal underworld of inverted bourgeois ambitions. A common marker of status and personal identity, the automobile's ingrained associations with freedom and power are renegotiated as confinement and paranoia. Stable shapes are frayed by the imposition of nighttime shadows or vertiginous camera angles; fixed perspective may be obliterated by reflections in mirrors or windows. Figures are sandwiched by window frames, faces encircled by steering wheels or awkwardly illuminated from below by dashboard lights. Seated side by side, doomed outlaw couples or hoodlum pals are typically cleaved by disparate lighting patterns or by close-cropped editing, their feelings of mistrust and isolation expressed through stylized images of fragmentation. The urban landscape viewed from inside the car—the characters' horizon of action—is similarly framed by black-edged borders or split into slices of harsh light and murky architectural facades. The noir automobile mediates a perceptual regime that conditions, and is inflected by, the dire subjectivity of its inhabitants.

The pervasive strangeness and ambiguity built into the visualization of automobiles is echoed in the narrative and thematic structure of noir. An analysis of nearly one hundred film noir made between 1944 and 1958 reveals that more than two-thirds feature automobiles as a prominent motif. Cars are employed not simply as a mode of transportation but are integral to a criminal activity or, alternatively, to the surveillance and apprehension of criminals. In nearly a quarter of these films, cars are directly enlisted as a murder weapon (*Scene of the Crime*, *The Woman on Pier 13*, *Roadblock*, *The Dark Corner*) or as the "scene" of murder or murder/suicide (*The File on*

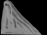

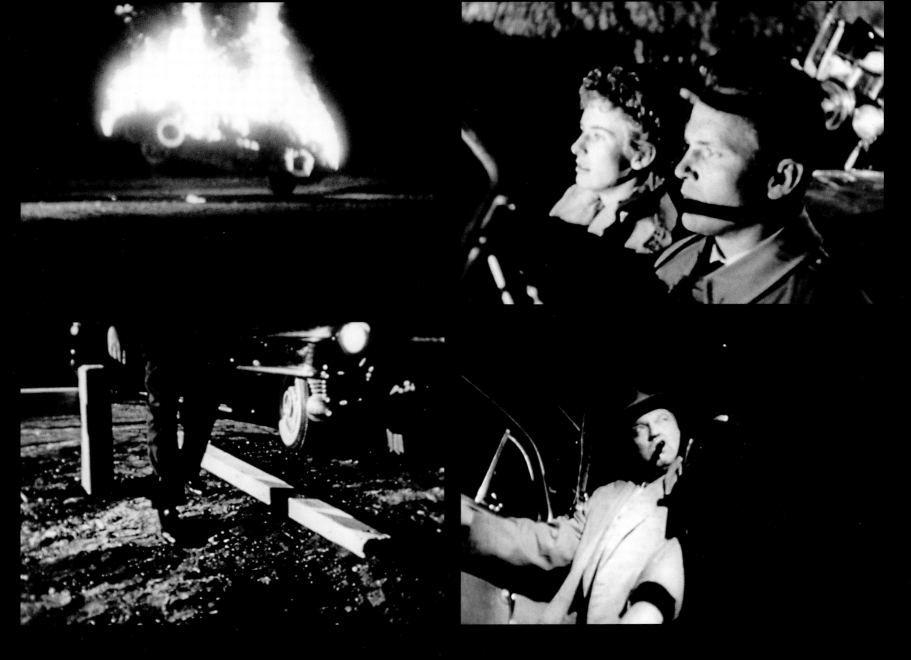

Thelma Jordan, Out of the Past). In a half-dozen films, corpses are laboriously stowed in trunks or backseats for eventual disposal (*Woman in the Window, Where the Sidewalk Ends*). Car bombs are a source of mayhem in *Touch of Evil* and *The Big Heat* while the cutting of brake cables or similar mechanical tinkering spell death in *Angel Face* and *The Undercover Man*. Cars are thus an integral part of film noir's extensive technologies of death, their armored bodies rife with harbingers of mortal destruction. Historically, film noir started to roll off Hollywood's assembly line at the end of World War II just as the Detroit industry (commended by FDR as the Allies' "arsenal of democracy") began the process of retooling for peacetime production. As is the case with other vectors of noir violence, like the explicit coding of characters as combat vets, the iconography of cars feeds off an anxious wartime rhetoric of "mechanized death."

The same patterns of narrative apply to films organized around the pursuit of criminals and the criminal pursuit of unlawful goals. Moreover, despite an overwhelming preference for male protagonists, women are as often in control of the auto's lethal potential as victimized by it. The narrative positioning of cars seems immune to distinctions of gender, legal status, or for that matter age and class. If cars are equal opportunity destroyers, they also figure in surprising ways as multi-purpose narrative settings. *Double Indemnity* provides the most diverse roster of functions. The lead character is a traveling salesman whose coupe doubles as a rolling office, fast-food dining room, and place of romantic liaison. It is also an important prop in the murder scheme concocted with his married lover, whose family car serves as the murder site, a de facto hearse. At a thematic level, it becomes a transformative arena in which the killer irrevocably assumes the identity (in nearly every sense) of his victim. A similar predicament is unveiled in *Detour*—although the death of the car's owner is "accidental"—suggesting that automobiles can help activate the classic noir hero's devastating slippage of personal identity.

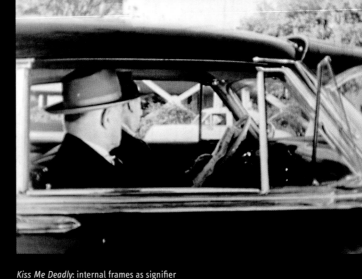

Kiss Me Deadly: internal frames as signifier of entrapment

As the bearer of secrets, conspiracies, dead bodies, and illicit sexuality, the noir car teems with unconscious desire, a super-charged space in which, as Freud explains, "that which should remain hidden comes to light." In film noir, the uncanny exists cheek by jowl with the quotidian. There are, for example, numerous instances in which cars act as observation posts for the gathering of evidence. Two different, weirdly voyeuristic forms of spying take place in *99 River Street* and *Walk East on Beacon*. In the former, a taxi driver who spends half the plot transporting a concealed body in the backseat, devises a scheme to trap a suspected murderer and watches from his cab as an actress friend feigns a seduction scene. In the latter, a "semi-documentary" noir based on actual government files, FBI agents install cameras in the headlights of a car in order to surreptitiously photograph a communist spy. Here the reflexive conflation of auto body and camera limns the degree to which the role of automobiles in film noir is sustained by the opposition of visibility and invisibility.

Suburbanization and the postwar housing boom, spurred by universal car ownership, are given an odd spin in movie images of the car as temporary domicile. Criminal couples in *Gun Crazy*, *The Prowler* and *Detour*, and a romantic triangle in *Raw Deal*, adopt the car as claustrophobic pseudo-apartment. Dramatic scenes — conventionally staged in domestic locales — are played against the moving backdrop of an open road. This convergence of domesticity with transient movement is brilliantly summarized in *Private Hell 36*, whose title refers to a rented trailer in which two rogue cops hide a cache of stolen money. In various cop-noir of the 1950s, including *On Dangerous Ground* and *Between Midnight and Dawn*, protagonists are briefly shown in permanent dwellings but due to marital conflicts (or lack thereof) they are able to communicate authentic emotions only in transit. For a private detective in *Out of the Past*, an automobile trip is the prescribed venue for confessing to his girlfriend nefarious events from the past. Here, as in other films, a road journey frames and internally calibrates the progress of an intermittent narrative.

Writing in the period just prior to the commencement of film noir, the philosopher Herbert Marcuse discussed the fetishization of the automobile in terms appropriate to noir:

> The average man hardly cares for any living being with the intensity and persistence he shows for his automobile. The machine that is adored is no longer dead matter but becomes something like a human being. And it gives back to man what it possesses: the life of the social apparatus to which it belongs.

The social apparatus to which the automobile in film noir belongs is composed of a bleak Darwinian underworld. Predominantly middle-class characters are subjected to a ritualized process of downward mobility resulting in actual or symbolic death, accompanied by a gradual and profound loss of personal identity. Cars are the quintessential icon in this fictive rite of passage, at once silent accomplice and mechanical nemesis. Instead of acting as a bright billboard for the dreams of postwar America, the car assumed the guise of a steel and chrome Minotaur patrolling the depths of a Cold War nightmare.

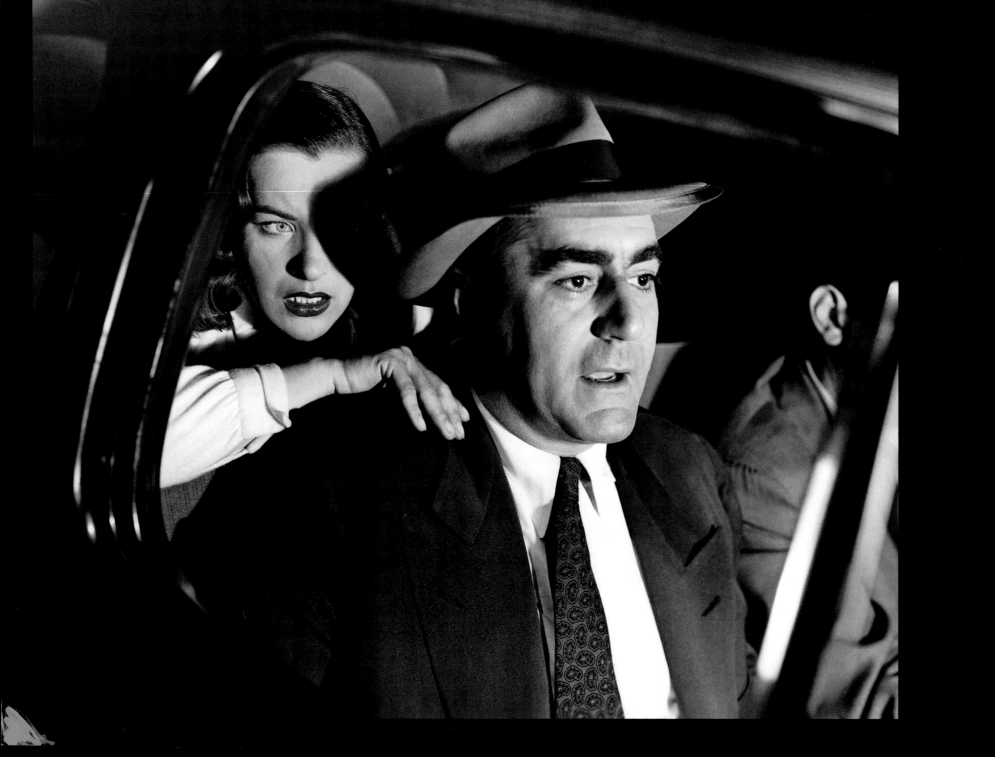

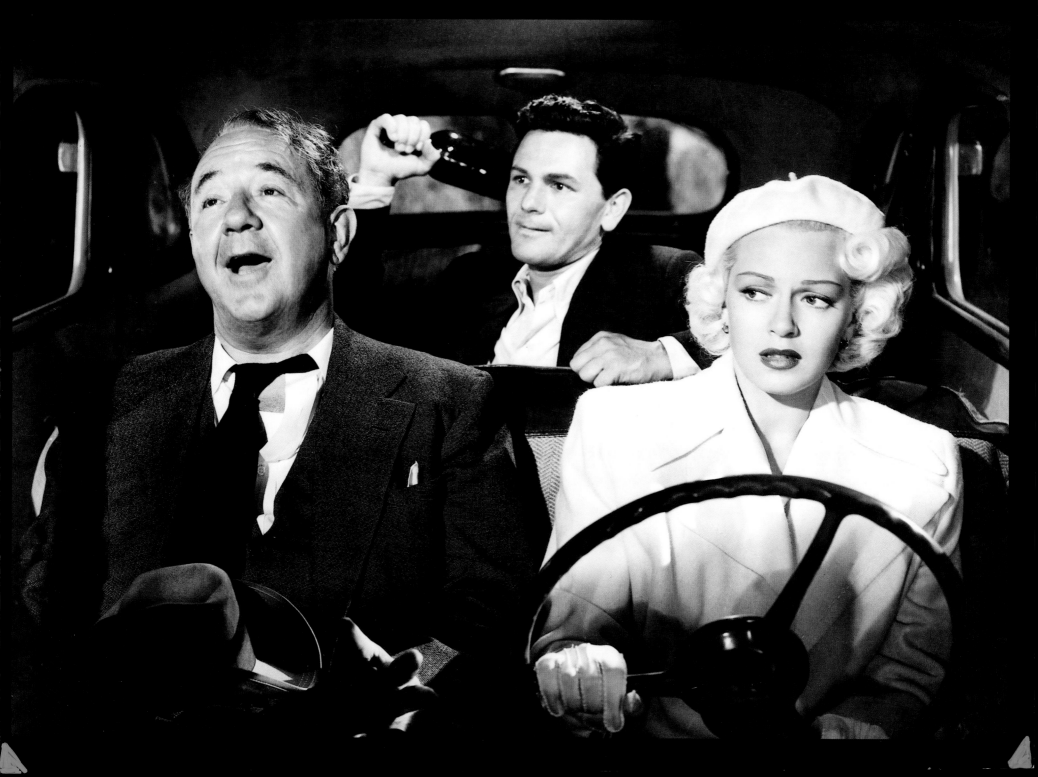

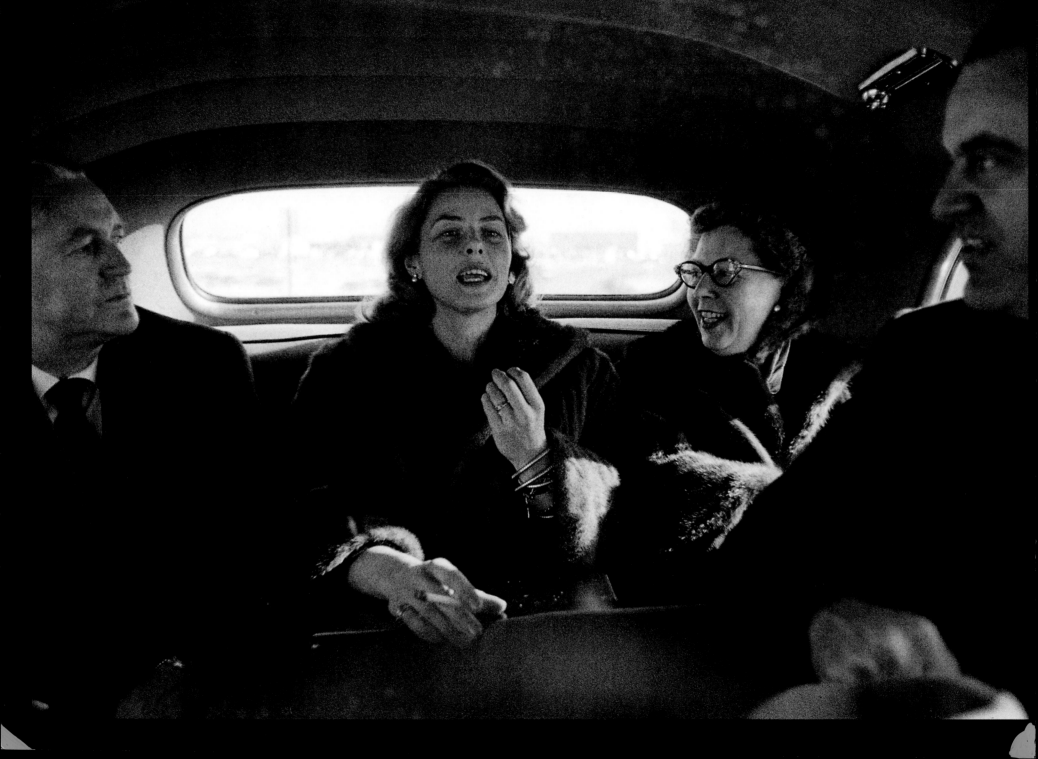

Death is in the driver's seat in film noir, the automobile itself nearly always painted black—a coffin on wheels. No one in these B movies ever slides behind the wheel humming a happy tune, eager to enjoy a summer picnic or a Sunday outing or some other carefree escape. In these black-and-white cheapies, escape is fueled by fear and pursued by the furies. Where slick magazine ads of the period made Detroit's latest models look like shiny and bright utensils on wheels, the atmosphere inside a film-noir getaway car is a foggy compound of cigarette smoke, cheap perfume, cold sweat, festering thoughts, and the clinging past. The backseat—the passion pit of high-school lore—is where betrayal springs its trap. In *Double Indemnity* and *The Postman Always Rings Twice*, both based on James M. Cain novels, the wife's lover hides in the back seat while the clueless husband sits in front, his fat head just begging to be knocked off. (Perhaps the most dramatic use of the backseat is in a non-noir, *On the Waterfront*, where it serves as a confessional as Marlon Brando bares his soul to Rod Steiger and turns the theme of betrayal into a wounded elegy.)

As America became more prosperous and expansive in the fifties, cars began to resemble surfboards with their fins and slick horizontals. The cars in film noir are bulkier, hulkier—humble clodhoppers. They go with the men's suits of the era, which seemed designed to cover as much acreage of Raymond Burr (one of the key villains in film noir, scalding a victim in Anthony Mann's *Raw Deal*) with as little pizzazz as possible. The springy elan of the great male action heroes of the thirties, embodied most exuberantly in James Cagney, coarsened in the forties and fifties to a thick, brute functionality. A lot of the male leads in film noirs seem barely actors at all, chosen instead for their interchangeable dullsville functionality, like the sleepwalking line-readers in Val Newton's horror films. As for the women—these

A Dangerous Profession, 1949. RKO Radio Pictures Inc. All rights reserved Photofest, NY

dames still command trim figures and tart understatement, a feline cunning conveyed through sexy slouches, painted claws, and appraising glances. No wonder a sneer of disgust often curdles their lips as they watch these overgrown boys drink themselves stupid and mess up their plans. You ask a guy to bump off your husband and next thing you know he gets all sloppy on ya.

Because film noirs were low-budget affairs, they dispensed with inessentials and decorative niceties, giving the images a stark, nocturnal lonesomeness. Traffic is almost nonexistent as a single pair of headlights illuminate the road ahead, giving the surrounding darkness a deeper coat of black. Hitchhikers pop up like apparitions. Sometimes the hitchhikers are homicidal psychos or prisoners on the lam, other times they're victims fleeing for their lives (as in *Kiss Me Deadly*), but they always suggest ghostly fragments of the unconscious the driver can't outrace. No sequence better distills the dread and isolation of driving at night into the unknown than Janet Leigh's spin behind the wheel in *Psycho*, when the rhythmic chop of the windshield wipers presages the fate in store for her at the Bates Motel.

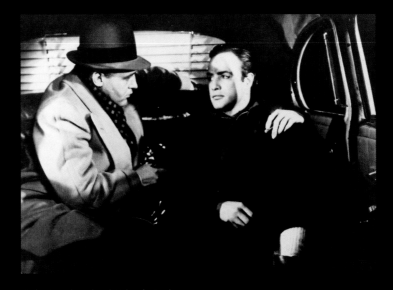

Marlon Brando and Rod Steiger in *On the Waterfront*, 1954. Columbia Pictures/Kobal Collection.

Right. Cecil Kellaway, John Garfield, and Lana Turner in *The Postman Always Rings Twice*, 1946.

Above. Ingrid Bergman in *Voyage in Italy* (Dir. Roberto Rossellini, 1953). Frame enlargement

Left. Jerry Dantzic, 1957. Ingrid Bergman in backseat of limousine on her return to New York. Also pictured are Buddy Adler, Kay Brown (her publicist), and Ed Sullivan (in front seat)

The car is not only endlessly represented in art and film but actually "drives" many forms of representations. Following this route, and looking at the kind of motor-force that the car embodies, we will highlight a particular function of this *topos* in the visual arts—a *transitive* driving force. As we embark on this critical journey, we select a particular angle of view out of the different perspectives and diverse functions that one could outline on the surface of the car. In fact, there are many ways to conceptualize the car, for this vehicle offers a variety of alluring options to cultural critics. The car is a commodity, an index of social status, a carrier of style, an object of fascination, and, at times, a fetish. As Kristin Ross has shown, one could even turn to the image of the car to read the history of a nation, its modernization, and (industrial) mobilization.[1] In many ways, then, we can say that the car drives social as well as aesthetic change. As we work within the range of this "driving force" of the automobile, there is a particular aspect of this proposition that comes into play from our moving perspective. It is the inner workings of the driving force that concerns us here. The car is a forceful representational apparatus, for it is itself a means of perceptual modification. The entrance of the car in our field of vision impacts the way we see, and not only in the visual sense, for it involves more than the sense of sight. The perceptual change wrought by the car invests all five senses, for we hear, smell, taste, and touch differently in the transport-bind with the machine ensemble. The car engages as well the motor-forces of imagination: it touches upon a vast range of inner metamorphoses. The car can be a means of passage, a site of liminality and a place of intersubjective transformation.

Film offers poignant cases of the way in which the car can "animate" the forces of change. In *The Getaway* (1972), a film written by Walter Hill, adapted from a Jim Thompson novel and directed by Sam Peckinpah, the plot follows a gangster couple on the run. This plot was developed previously in *Bonnie and Clyde* (1967) under the direction of Arthur Penn, but *The Getaway* adds

twist to the genre, and takes it onto a different route. It does so by charging—"investing"—the car with a set of affects. The car is not simply a tool of escape from the law. The extensive car-chasing and the long drives become a vehicle to reflect on the state of a "moving" story—the amorous relationship between the two characters.

In *The Getaway*, dialogue is sparse and takes place almost exclusively in the car. Here, the couple ruminate on their escape from each other, and the more they run away, and the farther they travel, the further they get from one another. The more physical distance they cover, the more emotional distance is created between them. At the end of the trip, there will be nothing left between them, unless they reverse the process that has been driving them. So, after a messy ride in a garbage truck, in a dramatic effort to escape from the police, they find themselves in a dump, and seek a car to take shelter in. Finally, they find respite in an abandoned, scarred, and broken-down car. The vehicle is cut in half, yet it still offers the privacy they need to reflect on their own broken lives. The cut-up car enables them to open up their own wounds. Enveloped in the surrounding interior of the vehicle, views from inside the car, and inside themselves, develop in parallel. At the end of this car scene, as in a movie theater, the couple has covered a great distance without actually physically moving. Riding the course of their relational distance, they eventually end up committing to each other, and choose to travel closer together. As they leave the vessel of the old car, they exit from a trip that has taken them far into another kind of vessel—an emotional artery, the flow of their relationship. In the end, they come out of the car ready to restart their own engine.

The Getaway is a forceful example of the use of the car as a vehicle of intersubjective introspection and transformation. It is not a unique example, for this topic is indeed well traveled in film. One particularly interesting case of this emotive morphing can be found in *Voyage in Italy*, directed by

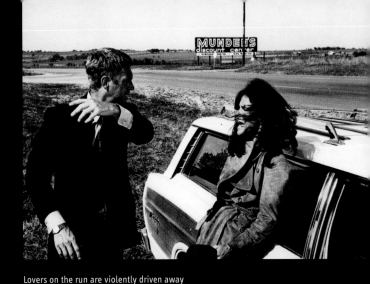

Lovers on the run are violently driven away from one another in *The Getaway* (Dir. Sam Peckinpah, 1972). Courtesy of the Museum of Modern Art, Film Stills Archive

Roberto Rossellini in 1953. This film was inspirational for Jean-Luc Godard, a director who offered his own versions of the transformative road movie, prominently staging it in *Pierrot le fou* (1965), and creating a landscape of "collision" in *Week-end* (1967). In particular, with the emotional journey of *Contempt* (1963), Godard remade Rossellini's *Voyage in Italy*, and offered a dazzling, deadly ending to its use of the automobile, with a stylized car crash in which the car itself became a space of aesthetic collision.

As the predecessor of *Contempt*, *Voyage in Italy* itself provides a frame for reading views inside the car. The film narrates the car trip of a wealthy British couple down south, to the warm landscape of Italy. The protagonists Alex and Katherine travel to Naples to deal with the aftermath of an uncle's death and to claim the house he has left them. While Alex wants only to liquidate the situation, Katherine embraces the trip and its deadly trajectory. On the road, they progressively grow apart, becoming strangers to themselves and to one another.

As one looks closely at the film's structure *Voyage in Italy* appears to be almost an excuse to transform various sites into emotional landscapes. The film barely has a plot: we simply follow the couple on their journey to Naples, and then go along the extensive road trips taken by Katherine, played by Ingrid Bergman.

Katherine drives herself through the city's long and narrow streets, which continually intersect. At every crossroads she looks through the car window at all that composes the city's moving geography. Priests walking under Communist party posters, women, children, animals, vehicles of all kinds, and everything else intersects, interweaving with her own journey. Her moving views from inside the car re-frame the moving panorama of an (un)picturesque city.

The moving panorama that Katherine pictures for us as she drives through the streets of Naples is a spatially defined pictorial landscape. She looks

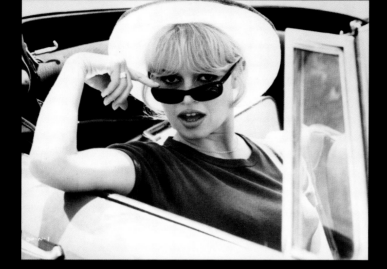

Brigitte Bardot looking out for herself, driving away from the scene of *Contempt* (Dir. Jean-Luc Godard, 1963). Copyright © 1964, Embassy Pictures Corp. Courtesy of the Museum of Modern Art, Film Stills Archive

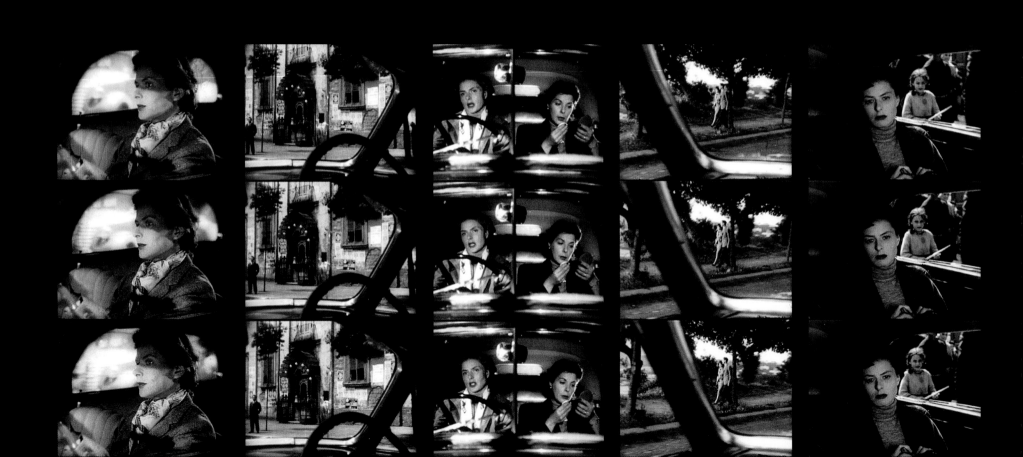

through the frame of her car window as if she were looking through the framed view of an older design object, a *mondo nuovo* box (literally "new world") — one of the pre-cinematic apparatuses that unraveled moving views of landscapes and cityscapes out of a box. The interior of the car becomes such an open box for viewing sites.

As Katherine drives her car through town, her sunglasses filter the site. As she moves along, looking out the car window, she allows us to catch a glimpse of the city. This is how we passenger-spectators get to know the streets of Naples — through her subjective viewpoint. Her views from inside the car are the only views of the city offered by the film. The streetscape becomes a projection of car travel. We are never permitted to exit the car and wander on our own through the streets of Naples: the camera is not allowed any autonomous freedom of movement. It only looks as she looks in her journey. A gendered outlook is thus constructed, mobilized as it is transposed onto a road trip. Ultimately, the camera sees what, and how, the woman senses: through the dark frame of her sunglasses, and the geometry of her moving car's windshield, in intersection with the screen's own frame. The stranger looks out at the city and into herself. She is "screening" something out, yet at the same time letting something in.

Katherine makes several excursions into town. In terms of plot, nothing really happens during those trips, yet an emotional narrative unfolds as Katherine traverses the archival fiber of the landscape, sculpting it into her own erotic space in a "tourism of emotions." Topophilically inspired by the porous geology of the site, with its hot eruptive terrain, Katherine embarks on a volcanic interior journey. This journey pulls her apart from her cold, insensitive husband, and would even take her away from the unhappy marriage, if she could just manage to stay the course.

Her journey is, literally and metaphorically, "driven." Moving through the landscape framed by the car window, and using her car as a vehicle for a physical, spatio-visual and liminal passage between inside and outside, she voyages closer and closer to an inner space. She plumbs her own geological depths and unconscious desires erupt. Moving further into the belly of the city, Katherine reaches her own underground. The geography, mobilized by the car, ends up producing sensational changes. She can now be in touch with her senses. Framing views in her drives, Katherine becomes finally able to design, and change, her own landscape.

This narrative framework is indeed well suited to the filmic frame, and suggests an affinity between film and art. In fact, the type of representational journey exemplified in *Voyage in Italy* extends to contemporary artistic practices: the car is pictured as a vehicle of interpersonal voyage in a variety of artistic mediums. If one considers the role of the car in the history of film, one can better understand the urge of the artist Sophie Calle to make a special kind of "road movie," one which itself travels a particularly moving route — the course of a relationship. *Double Blind* (1992), a film made by Sophie Calle and Gregory Shephard, records their car trip across the United States. Calle, who has always worked with narrative in photography, and is much concerned with detecting, surveying and investigating intimate space, created with her partner a road movie that takes us on the road to a relational transformation. The views inside the car that we see are actually views inside the characters' own vision of their disintegrating love affair. Here, the different perspectives on the matter develop as each of the protagonists authors his or her own movie of the story they live and traverse on the road.

The examples of these films lead us to reflect on the car as a metaphor, that is, following the Greek etymology, as a complex means of transport. They show that a car window can "frame" an interior landscape and that taking the road can open up a route of emotional transformation. In this respect, the car window, in some way, can be seen as a double of the filmic frame. After all,

Film theory, the screen has often been compared to a window, a picture frame or a mirror. The parameters of this discourse have been recently expanded in cinema studies, following the contribution of cultural historian Wolfgang Schivelbusch, who first compared the spatio-visual apparatus of railroad travel to that of the cinema.[2] Retracing the origin of the film screen back to the mobilized view of the train is relevant to our concern for picturing the representational forces of the car. In a genealogical sense, one could say that the film spectator is him/herself a "passenger," for both the train, the cinema, as well as the car involve a profound change in the relation between spatial perception and bodily motion, a change operated by a moving view from a framed window. Pursuing this comparison in work on filmic (e)motion, I have explored more extensively elsewhere the vast extent of the voyage between inside and outside that is accessed in the movie house, and mediated by this *topos* of the window.[3] This exploration involves making a set of journeys into art. An art-historical detour is particularly useful here, for it can make us grasp the kind of perceptual "architecture" that the car itself embodies. When we look at this issue with art-historical eyes, we realize that what we see through the frame of the filmic window-screen, and the car's window, is a world in motion which emerges out of the painterly tradition of the framed view. It emerges out of the representa-tional space of early modernity that was especially developed in *vedutismo*, the art of viewing. This aesthetic cannot be understood in optical terms alone. It is a matter of moving sites and not only an effect of sight. Hence, moving away from the strictly optical considerations that have dominated the work on the framed view, and thinking of *sites* more than *sights*, we can point to a "site-seeing" as it joins car and film travel on the surface of the window-screen.

 In a related sense, we can also recall some of the specific architectural history of the kind of window that has become the car window. As Paul

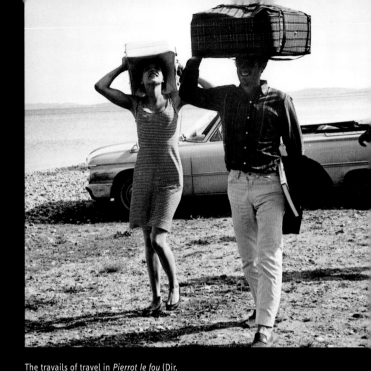

The travails of travel in *Pierrot le fou* (Dir. Jean-Luc Godard, 1965). Frame enlargement. Courtesy of the Museum of Modern Art, Film Stills Archive

"The sex appeal of the inorganic": view from the car, *Made in U.S.A.* (Dir. Jean-Luc Godard, 1966). Frame enlargement

Virilio points out in an essay on automobile culture, significantly entitled "Dromoscopy," the window must be seen in relation to its architectural function: the window appeared in places of worship to provide openings to the sky and the environs, and similarly functioned in pictorial history, before becoming the "screen" of the dashboard. Furthermore, as he puts it, "with its rear-view mirror, its windowed doors, its frontal windshield, the automobile forms a quadriptych where the travel lover is the target of a permanent assault which renews the perspective of painting. The illusion is the same, but henceforth it extends itself at the surface of the world and no longer only on the surface of the canvas."[4] Given the spatio-pictorial bond that takes place in the frame of a window, it comes as no surprise that art would creatively re-turn to the journey of the window, and to car travel.

The extent of such a journey is far-reaching: it cannot be fully explained by the framework that Virilio ends up adopting, as he encloses his own argument, and ultimately restricts his view of the car to assault and illusion. But the matter of windows cannot be simply reduced to a sight of perspectival assault or illusion. The pictorial and architectural windows-screens surround and open up to a much bigger "design" and a less negative space: they challenge and reframe notions of inside/outside, and, by extension, divisions between private and public. In this sense, they enable us to voyage within and inbetween these sites. Most importantly these windows-screens which are open onto the outer world are also portals into our inner selves. Both these landscapes are shifting sites themselves, and change along with the apparatus that mobilizes them. In this respect, both the car window etched in contemporary art and the film screen, re-viewed as the epitome of modernity's window, project our states of mind. Their frames are, indeed, frames of mind. They construct and negotiate within their boundaries voyages of identity, narratives of selfhood, vicissitudes of intersubjectivity,

Ultimately, the car and the cinema are both a site of "transport," in the largest sense of the word. As a literal and virtual mode of transportation, they are both vehicles of passage—a place for "drives." Indeed, it is interesting to note how the psychological dimension of the word *drive* is associated with a motion that is internal. A drive is an instinct, an inner urge, an energy with a direction. It is a thrill, an experience of internal motion. A drive impels matter by physical force, and carries us through and away. Under its action, it makes us float along and drift. It is ultimately a force to move on. The car and the cinema live as such "driven" places, where one not only can take a drive but is equally and forcefully *driven*. They are sites for the kind of carrying away one experiences in (e)motion, vehicles for the type of emotional transport epitomized in such moving expressions as transports of joy. In other words, as the filmmaker Douglas Sirk concisely put it, "motion is emotion." And such is, precisely, the view inside the car.

1 See Kristin Ross, *Fast Cars, Clean Bodies: Decolonization and the Reordering of French Culture* (Cambridge: MIT Press, 1995).
2 See Wolfgang Schivelbusch, *The Railway Journey: The Industrialization of Time and Space in the Nineteenth Century* (Los Angeles: University of California Press, 1986).
3 See Giuliana Bruno, *Atlas of Emotion: Journeys in Art, Architecture, and Film* (London and New York: Verso, forthcoming 2001).
4 Paul Virilio, "Dromoscopy, or the Ecstasy of Enormities," *Wide Angle*, special issue "Cityscapes II," guest editors Clarke Arnwine and Jesse Lerner, vol. 20, no. 3, July 1998, p. 18.

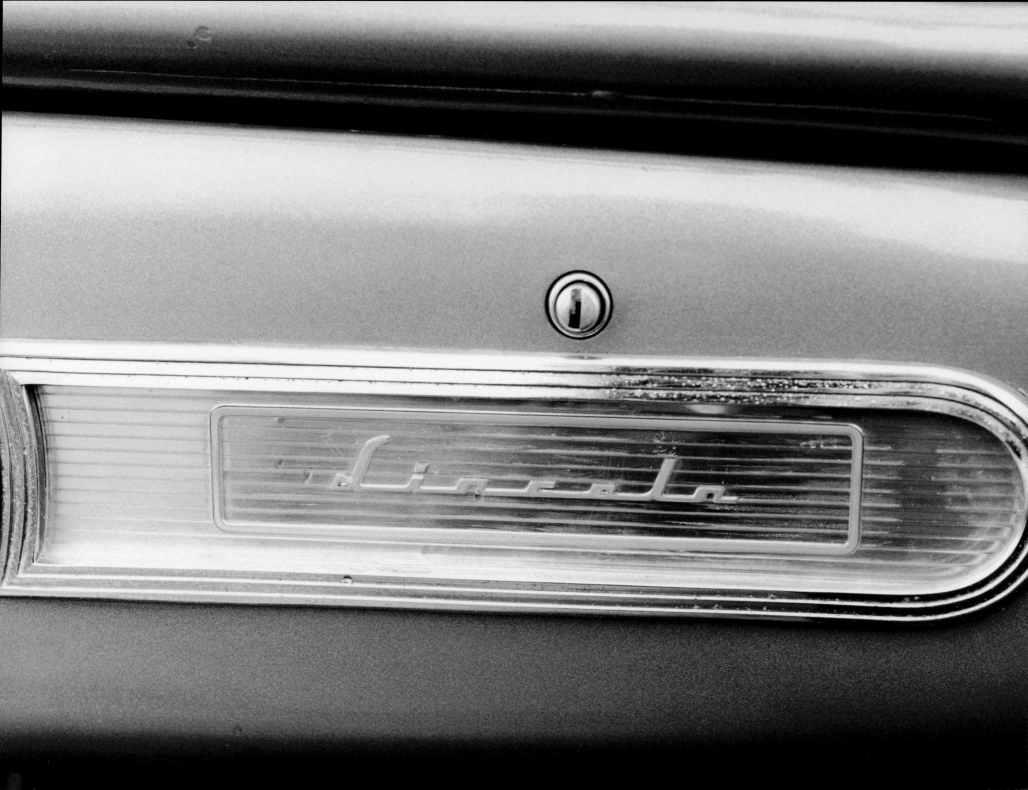

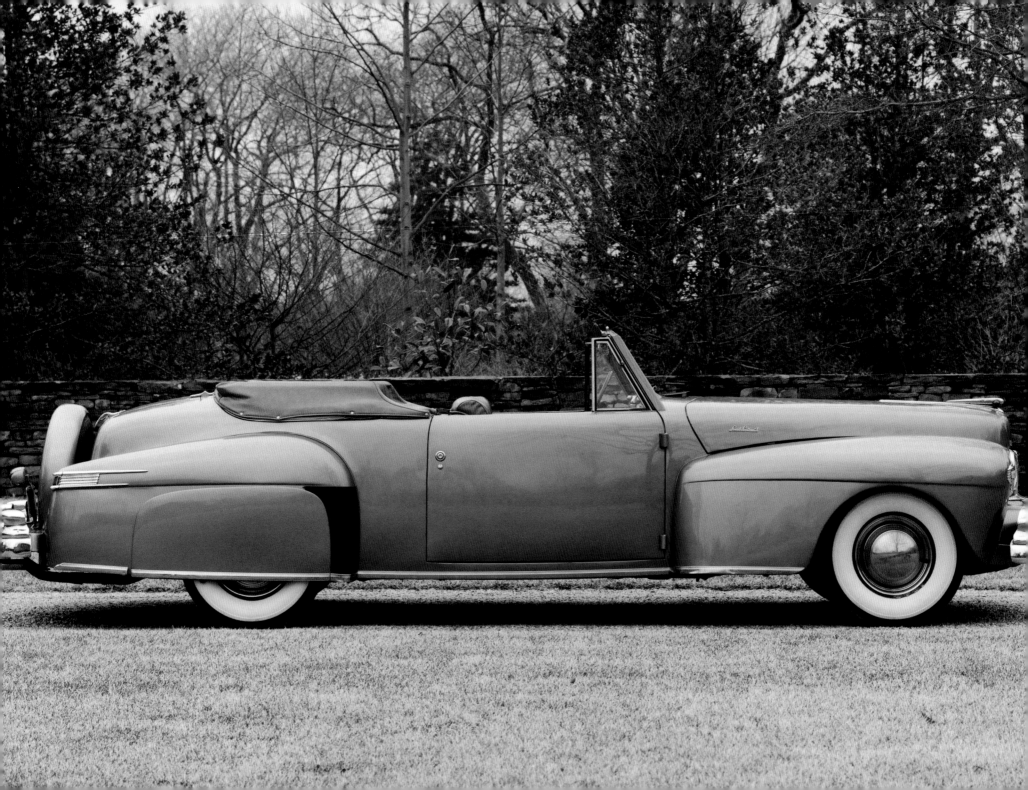

The 1948 Lincoln Continental Cabriolet portrayed in these photographs was originally owned by Hollywood legend D.W. Griffith, whose wife, Mrs. Ella M. Griffith is cited on its March 3, 1948 bill of sale. The car's "Jadite" finish and maroon Bakelite steering wheel and gear shift—as well as the entire contents of its glove compartment—have been lovingly preserved. The car was purchased from Griffith's granddaughter by a collector in 1998 in honor of his wife's 50th birthday (the car and the wife being the same age).

Lincoln **DEATON MOTOR COMPANY** *Mercury*

8955 OLYMPIC BOULEVARD
BEVERLY HILLS, CALIFORNIA

CRestview 18175 BRadshaw 22774

TO MRS. ELLA M. GRIFFITH (Registered to: DATE MARCH 3, 1948
 1041 North Formosa Avenue
 1736 OLIVE AVENUE Los Angeles, 46, Calif.)

 SANTA BARBARA, CALIFORNIA INVOICE N⁰ 1565

1 NEW 1948 CONTINENTAL CABRIOLET		$5063.78
	White sidewall tires	26.31
	Contl Heater	84.20
	Radio	196.40
	Overdrive	100.57
Install	Life Guard Tubes	68.80
		5440.06
	California sales tax	136.00
	Registration & vehicle license fee	72.00
	Lusterize	10.00
		5658.06
	down payment. . . .	1000.00
		4658.06

MOTOR #8H 181 488
COLOR: VALLEY GREEN
UPH: CUST INT TAN-TAN TOP
KEYS: Ign FK 039
 Glove Compt)
 Rear Deck)
5 Firestone tires

ck to apply. 4593.42

balance due. 64.64

RECEIVED PAYMENT
MAR 3 - 1948
DEATON MOTOR COMPANY

Per F Knight

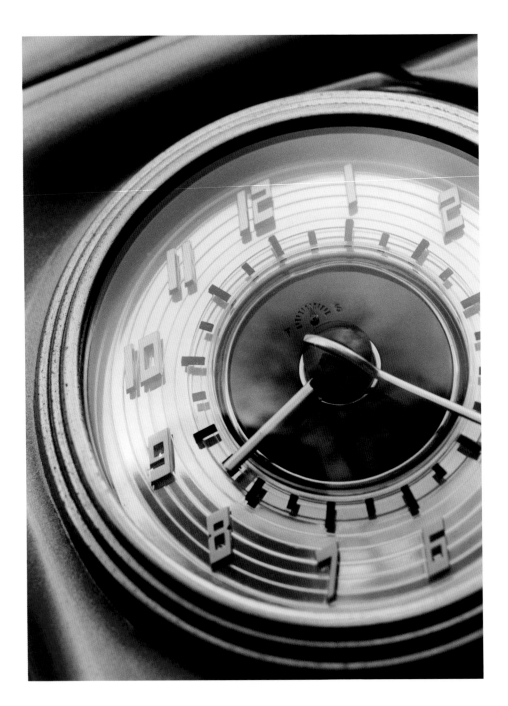

IMPORTANT! FOR SERVICE RETURN TO AUTHORIZED SERVICE STATIONS.

Time & Instrument Co.
57 Richards Street
Salt Lake City 1, Utah

Smith's Clock Shop
1016 W. Adams
Phoenix, Arizona

Donovan Auto Clock Service
6811 Melrose Ave.
Hollywood 38, California

Auto Electric Limited
3429 Park Avenue
Montreal, Canada

Beattie Auto Electric, Ltd.
176 Fort Street
Winnipeg, Manitoba, Canada

Auto Electric Service Co., Ltd.
1009-1027 Bay Street
Toronto 5, Canada

Boultbee, Limited
1025 Howe Street
Vancouver, Canada

PRINTED IN U.S.A. 21119

6

This is a

Genuine

BORG

ELECTRICALLY

WOUND CLOCK

•

Manufactured by
Borg Products Division
The George W. Borg Corp.
U.S.A.

Makers of
AMERICA'S FINEST
MOTOR CAR TIME PIECE

INSTRUCTIONS FOR REGULATING AND SETTING HANDS

A slight loss or gain in time keeping becomes accumulative over a period of days. Therefore it is advisable to set the hands of this clock occasionally as in the case of a good watch. Before leaving the factory this clock was fully regulated. It is possible that handling since that time has affected its close timekeeping. If so, regulate as follows:

If the clock runs fast, turn the regulator lever toward "S"; if slow, toward "F". One graduation of the lever, will make a difference of about one minute per day.

Note—In some automobiles the regulator lever is protected by a small round cover. To expose the regulator lever merely pivot the cover to one side and make necessary adjustment.

TO SET THE HANDS push in or pull out set button as required; and turn in desired direction.

2

IMPORTANT! FOR SERVICE RETURN TO AUTHORIZED SERVICE STATIONS.

The George W. Borg Corporation
Factory Service Department
469 E. Ohio Street
Chicago, Illinois

Clark Bros. Instrument Co.
10300 Whittier Ave. & Somerset
Detroit 24, Michigan

Schreiber Auto Clock Service
1610 W. Center Street
Milwaukee 6, Wisconsin

Empire Clock Service
93 E. 5th St.
St. Paul 1, Minnesota

Jack Harrison's Speedometer Service
3126 Locust Street
St. Louis 3, Missouri

Automotive Clock Repair Co.
666 Southern Boulevard
Bronx 55, New York

Boston Speedometer Service Co.
116-120 Brighton Ave.
Boston 34, Massachusetts

3

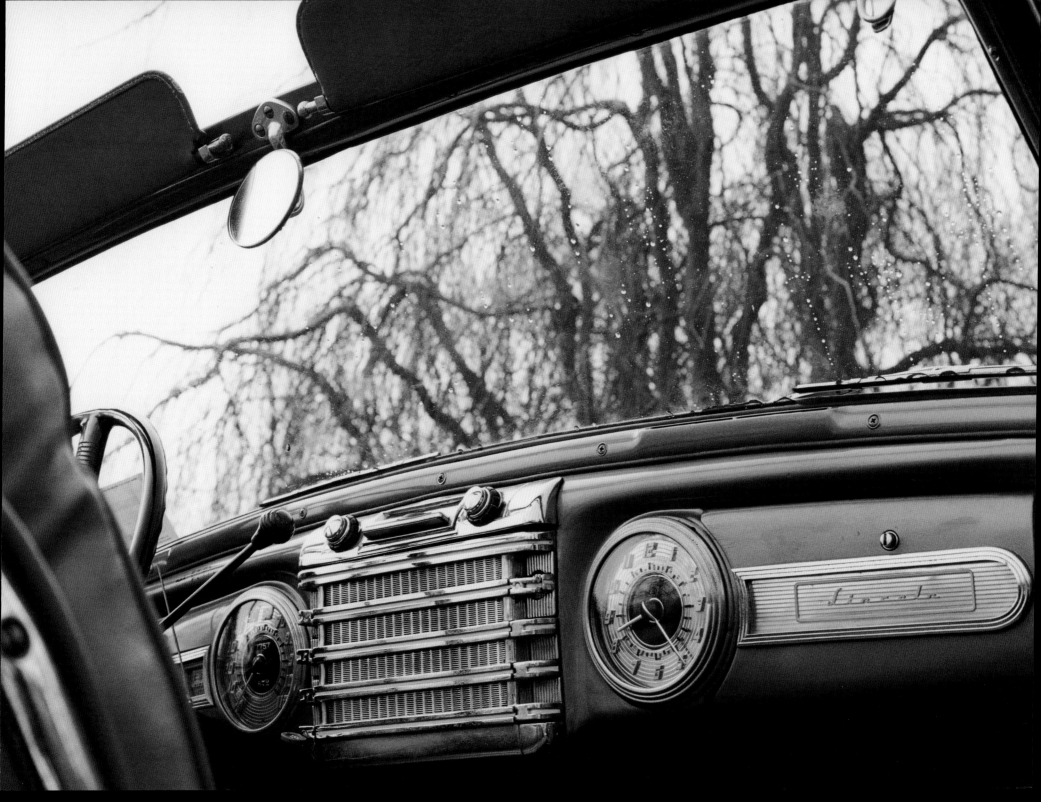

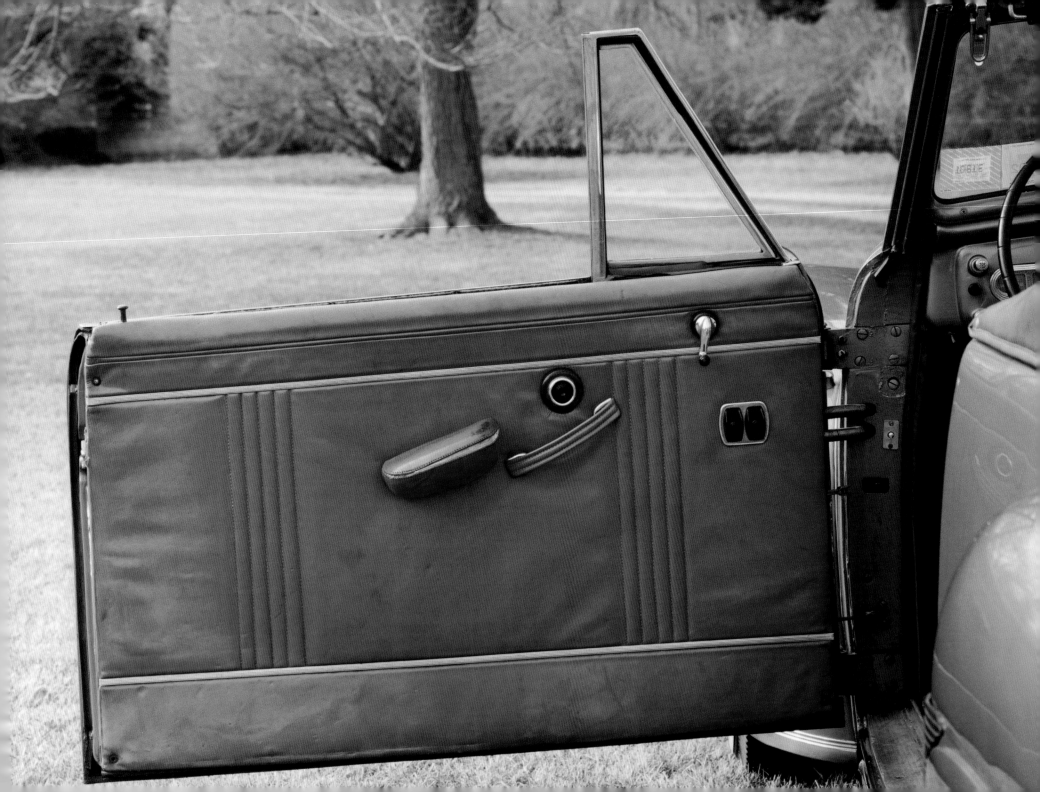

DEALER—Fill this tag in properly in ink and attach to the radio in the car. This tag must be attached to the radio in order to obtain free warranty service if required during the initial 90 day warranty period.

WARRANTY REGISTRATION

MODEL
7ML781

LINCOLNz
CONTINENTAL
AUTO RADIO

SERIAL NO.

OWNER — PRINT NAME

ADDRESS — CITY — STATE

PURCHASED (DATE) — FROM (DEALER'S NAME)

ADDRESS (DEALER'S)

(Read Important Instructions on Other Side.)

OWNER'S MANUAL

INSTALLATION AND OPERATING INSTRUCTIONS

LINCOLN

1947

ADJUST-O-MATIC

RADIO

with Foot Muting and Tuning Control

Lincoln Part No. 6H-18805-A
and
Lincoln Continental Part No. 6H-18805

LINCOLN-MERCURY
Division of Ford Motor Company
Detroit, Michigan, U. S. A.

THIS MANUAL SHOULD BE GIVEN TO THE OWNER

202-529-R
Printed in U.S.A.

GLOVE COMPARTMENT

TOBI TOBIAS / PHOTOGRAPHY JOSEPH MULLIGAN

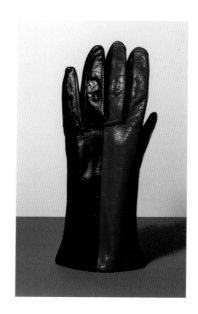

Glove compartment. "A small storage container in the dashboard of an automobile," the fourth edition (2000) of the *American Heritage Dictionary of the English Language* instructs us. But we knew that already. We know, too, that the glove compartment is vanishing or at least reconfiguring and relocating, as its traditional place, opposite the suicide seat, has been appropriated for air bags designed to preserve the life of the driver's number-one passenger.

What we're curious about is not the definition of the g.c. (nickname, invented) but its meaning—that is, its implications. Arguably the most personal part of a car, the glove compartment suggests the secret and the sexual. As a container sheltered in a larger—but still human-scaled—container, it proposes a parallel to the womb within the female body. Significantly, it can be locked. This capability augments its potential as a cache for the private, the intimate, the forbidden. Even when the g.c. is not locked, its default position is closed; left open, it's an image of careless-ness, slovenliness, or—worse—invasion. Cars that have been broken into often have their g.c.'s pried open, contents spewing out onto the door-cum-shelf, which hangs askew from its violated hinges. Our paranoid, techno-dizzy age has risen to the marauders' challenge with high-security g.c.'s (16-gauge steel! exclusive Pry-Guard locking system! none of your gimcrack stuff!). Ironically, the times have also suffused them with nostalgia-laden glamour. You expect this evocative piece of car furniture to figure in novels by F. Scott Fitzgerald, where love, luxury, and longing dance together, forever beyond reach. The association of the glove compartment with a paradise lost persists despite the more-often-than-not prosaic contents of the safe-deposit box on wheels.

The actual contents of most glove compartments can be neatly divided into two categories: the Logical and the Absurd. "Logical," the dominant division by far, comprises items likely to prove useful on a trip: identification

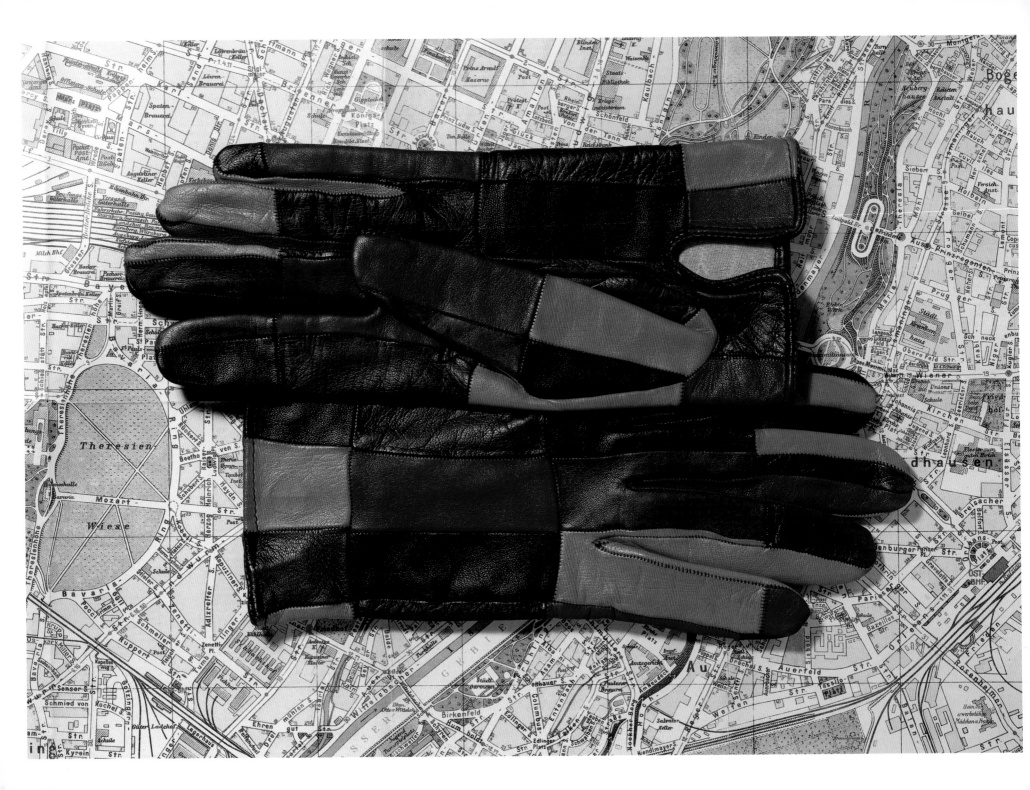

for car and driver; maps of the route; sunglasses to cut the glare; flashlight to illuminate the darkness; auto repair manual; first aid kit for the minor mishaps and occasional emergencies of daily life in transit; toiletries—the tools of a quick make-up-/over and, suggesting closer social contacts, a pharmacopoeia ranging from breath mints to condoms; provisions for entertainment (audio tapes, CDS) and refreshment (cans of soda and beer, low-end candy bars, designer chips); and, just perhaps, driving gloves, though these last lie even further down the road to the Museum of Memories than the g.c. itself.

The "Absurd" sector ranges from the Accidental and Ridiculous (misplaced lunch-box banana, plastic snakes and tarantulas deposited by jokester riders) to the hauntingly Metaphoric. This last subset provides an apt label for what the novelist Lynne Sharon Schwartz tells me she'd put in *her* hypothetical g.c.: "things I'd pack there if I were running away from home"—in other words, the lucky charms of one's aspirations to freedom, or at least otherness.

Apparently what you *don't* want to have in your glove compartment is a gun. No less an authority than the Supreme Court has decreed that "the phrase 'carries a firearm' applies to a person who knowingly possesses and conveys firearms in a vehicle, including in the locked glove compartment or trunk of a car.... As a matter of ordinary English," the august judges continue, with an unexpected interest in linguistic niceties, "one can 'carry firearms' in a wagon, car, truck, or other vehicle which one accompanies. The word's first, or basic, meaning in dictionaries and the word's origin make clear that 'carry' includes conveying in a vehicle. The greatest of writers have used 'carry' with this meaning, as has the modern press." Be advised.

One would assume that, like a purse or briefcase, a glove compartment might provide a telling portrait of the person (gangster, poet, vamp) who fills it. But the admittedly limited survey I made among my car-owning acquaintances yielded only the most prosaic replies (see "maps," "CDS," above) to the question of what they stash there. I soon understood that folks are unlikely to reveal (and to a writer on assignment, no less!) the quirkier, kinkier items in their g.c. inventory. As is inevitably true, I realized, more lavish results were to be obtained by conjecture. So I set about imagining what celebrities of the factual and fictional worlds might harbor in their g.c.'s and I'll conclude my report with the list below—to which the reader is urged to add. Performed solo or in the company of others, such speculation may help to alleviate the longueurs of the endless, uninflected highway on which we—gangster, poet, vamp, et al.—spend an inordinate portion of our lives.

ANNA KARENINA: Miniature portrait of her son, Seryozha, as a baby; single leather riding glove belonging to Vronsky; half-empty vial of opium; timetable of the Moscow branch lines.

ISTVAN BANYAI (*Zoom; Re-Zoom*): A miniature diorama of the car's interior, showing an open glove compartment containing a miniature diorama...and so on.

TOAD of Toad Hall: Map of the Wild Wood and Surrounding Country; driving gauntlets, goggles, and cap; summonses (various dates) to appear before the Bench of Magistrates on counts of stealing a motorcar, driving to the public danger, and gross impertinence to the rural police; "Song of Myself" by Toad (holograph copy); laundress disguise.

HAMLET: A cache of dog-eared softbound books, namely: *University of Wittenburg: Course Offerings; Spooked! A Layman's Guide to Paranormal Phenomena; Elementary Otology; Elementary Toxicology; Help for the Dysfunctional Family; Decision Making for Dummies; The Language of Flowers; Manual of Water Safety; Actors' Equity Directory of Itinerant Entertainers; Swordsmanship for Intellectuals; The Oresteia.*

CINDERELLA: The other glass slipper.

ST. JUDE (patron of lost causes): Road maps; condoms.

LAO TSE: Nothing.

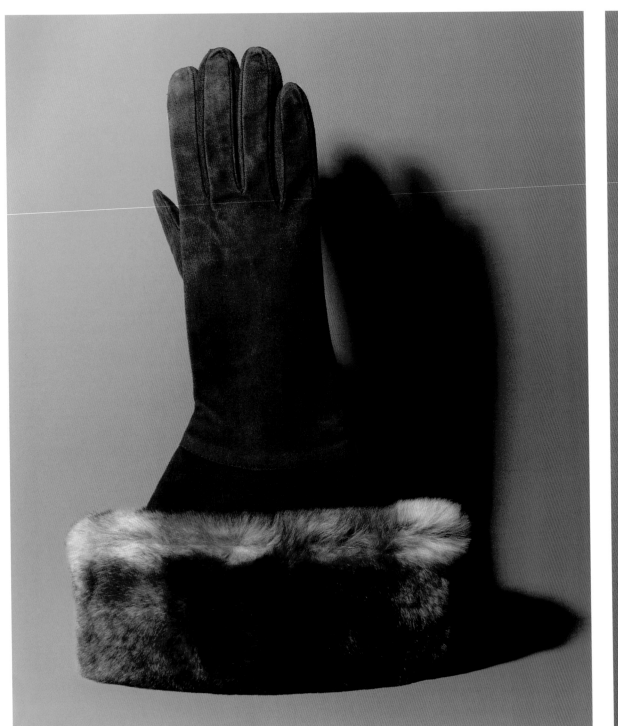
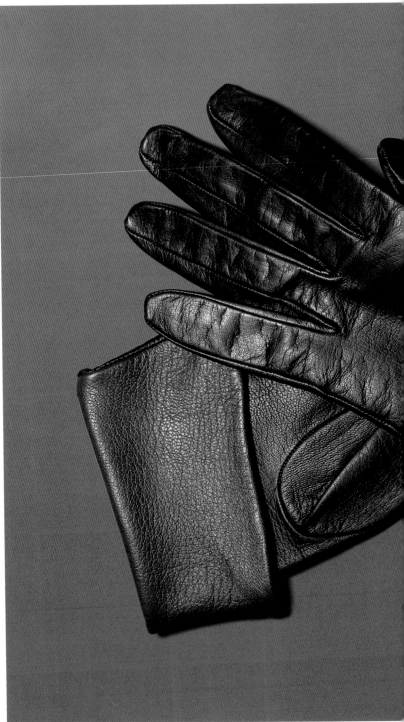

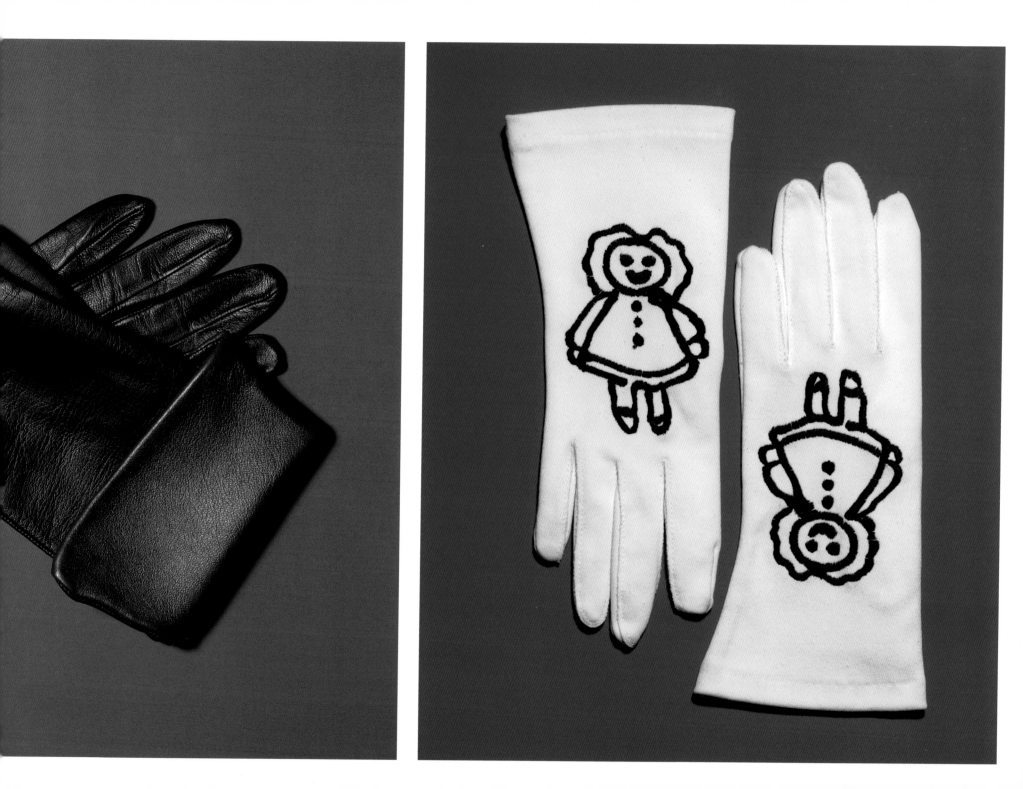

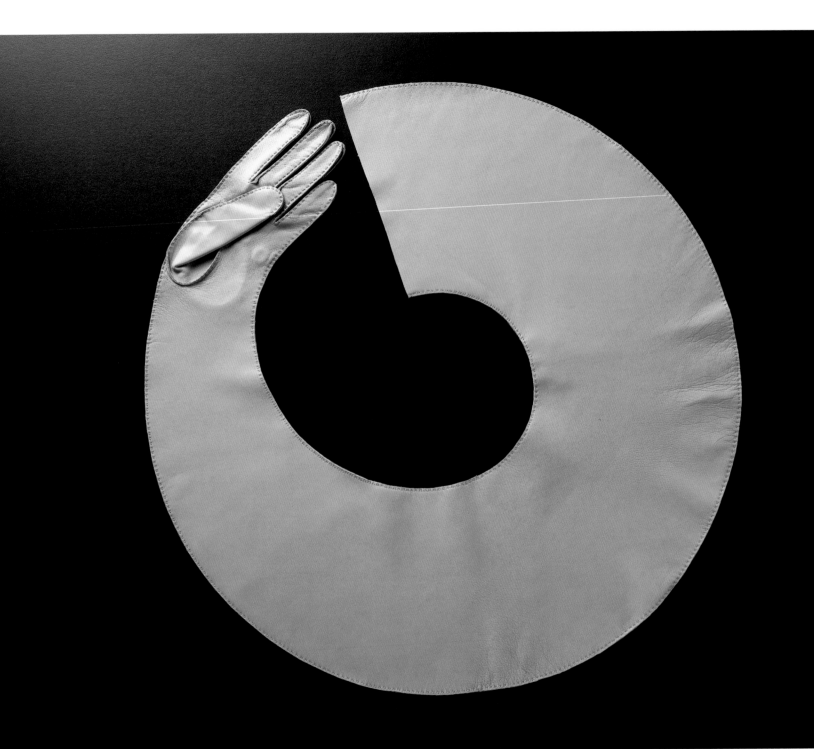

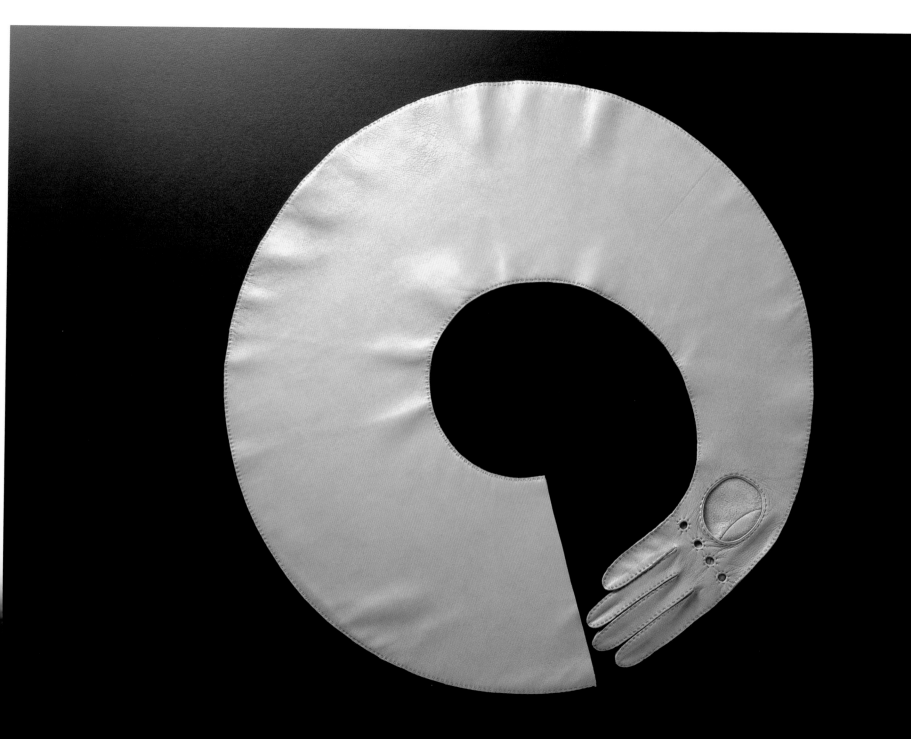

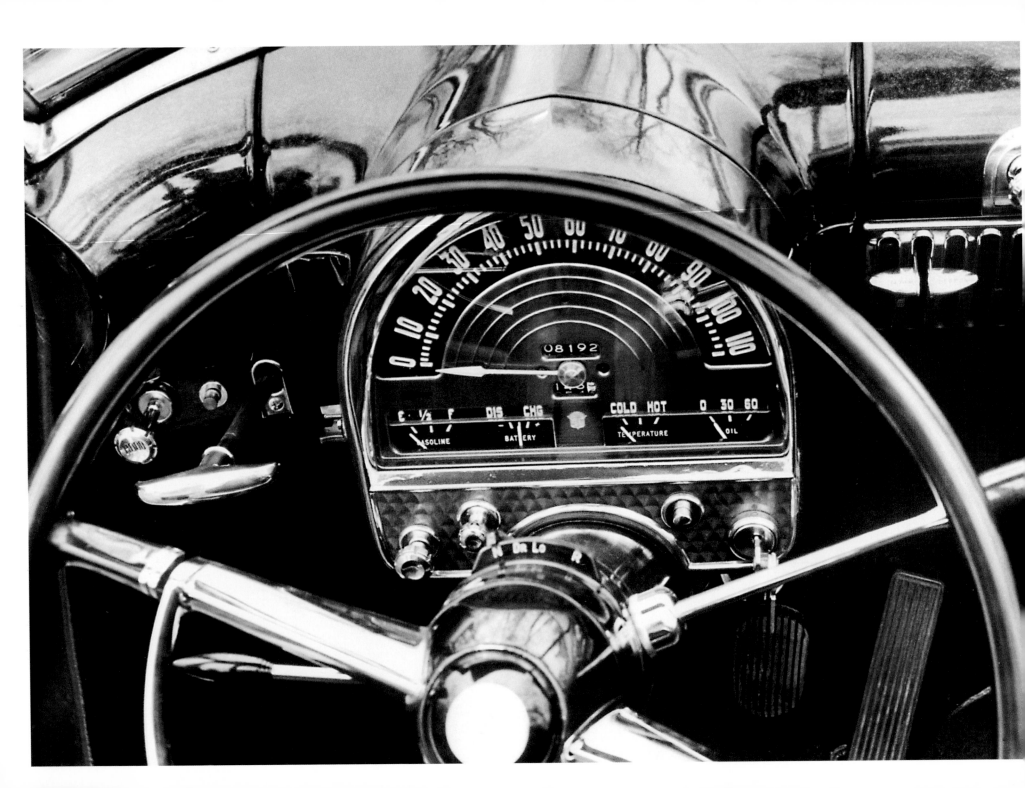

CONTROL PHIL PATTON

One day in 1916, the artist Henry Matisse asked his son and driver, the 16-year-old Pierre, to pull off the road along which they were driving in the south of France. Matisse painted the scene—perhaps the first artistic view out of an automobile interior. That Matisse, an artist fascinated with ambiguities of space and surface, of windows and mirrors, of decoration and depth, should have been attracted to the automotive interior so early was an augury of the future.

Not only would the car interior become a focus for artists interested in its experiential and perceptual issues, but those issues would shape its design. The automobile interior soon began to be designed in recognition that it was a space where representation—needles and gauges, symbolic materials and shapes—interacted in a very modern way with experience and perception, with consciousness ruled by motion and speed. Interacted, in short, very much as symbol and perception interacted in the most interesting modern works of art.

Psychologically as well as aesthetically, by the 1920s the special space of the automotive interior demanded the services of professional designers, first carriage makers and engineers and then stylists. It was a new kind of place, a modern space framing visions of the landscape but also a cockpit for information represented in new ways. The automobile was armor, carapace but also domicile—a kind of castle on wheels.

Cornell Capa, 1948, Interior of car, photo courtesy Cornell Capa/ TimePix, NY

In Matisse's hands, the view from inside the car turns the perspective of the road ahead into two painterly lines. He depicts a vehicle not far removed from a carriage or a railway compartment, its interior a boxy space. The painting shows the fenders and headlights of the car just visible ahead. The lights are still oil or acetylene lamps. Only in 1916 in the US did Cadillac introduce electric headlights. We see the steering wheel, which only a few years before had beaten out the tiller as the standard controlling mechanism. We see the rubber bulb of the hand operated horn. But any gauges in the original have been left out of the painting.

We can tell, just barely, from an ambiguous ripple in the windshield that it is one still made of two panels of glass joined in the middle. But the fact that this car was closed at all was still exceptional in 1916. It took a long time before the automobile was covered by anything more than a folding canvas top. The first form of auto interior design was wardrobe: dressing to drive or ride, to defeat rain and wind and dust. Alfred Sloan, the executive who brought design to General Motors, considered the creation of the closed car as one of the often overlooked landmarks in the history of the automobile.

The automobile was of course first of all the horseless carriage, and for a long time shared the symbolism, social and otherwise, of the carriage world, with its landaus and phaetons, victorias and chaises. These variants meant as much to the eye of the pedestrian in the nineteenth century as the social and economic gradients of automobile types mean to us today.

The term dashboard—like so many automotive terms—derives from the terminology of the carriage. The panel against which mud from the horses "dashed," it was one of the first features of an automobile to serve as a stylistic differentiator, in the case of the famous "curved dash" Oldsmobile of 1902, whose dashboard swept up in a curve, rather like the front of a sleigh.

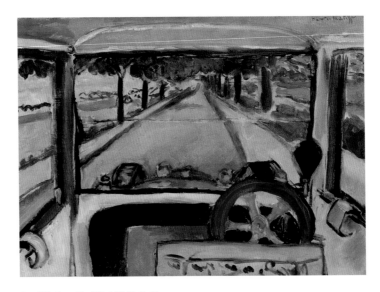

Henri Matisse, *The Windshield, On the Villacoublay Road (Le parebrise, Sur la route de Villacoublay)*, 1917, oil on canvas, © The Cleveland Museum of Art, 2001

⇦⇨ The persistence of the carriage legacy is evident in modern interiors, and our persistent affection for wood inside our vehicles. Wood still signals luxury, even when it is simulated. And when the burled walnut or bird's eye maple or smoked zebrano is actually real, it is sliced to microscopically thin veneer to avoid the warping and splinters of real wood.

In front of the dashboard of a carriage stood horses; in front of the dashboard of an automobile, the new motive power of the gasoline engine. In his wonderful book *Dashboard* (Phaidon Press, 1995), David Hollins documents the way in which the dashboard evolved. Early dashboards were basically wooden surfaces with a few gauges and controls attached to them. Soon the instruments were clustered into a metal inset, a kind of window into the operation of the engine ahead.

Today, we expect a predictable set of gauges, gasoline, temperature, speed, perhaps engine RPM. But the early gauges, resembling scientific equipment, presented electrical amperage, gasoline supply, speed, engine revolutions, and oil level with little consistency.

Gordon Murray, the technical director of McLaren cars, wrote that the instrument panel on the dash "represents the only link between the machinery and the driver—in short, nothing less than a visual lifeline of information transfer."

The dashboard in other words was an early example of what we would today call an interface. As such it had to adopt conventions of symbolism. The clock was the model for the gauges that measured gasoline, amperage, and oil. Their descendants today gleam and glow on our dashboards in iconic form—the tiny headlights, the little batteries with their plus and minus sign, the stylized oilcans and fans. The evolution of design conventions on the dash has been slow and uneven, but today the symbols we see inside the car largely constitute an international iconic system. The symbols glimpsed on the dash beneath the windshield are as readable as the icons of international road signs.

From the first crude elements set into the wooden dash, the instrument panel soon became a focus of design. When design professionals took over in the 1920s, they brought to the inside of the car the same effects of highlight and shadow that dominated the design of the outside.

They also became theater, for the dashboard was not just an interface with a mechanism but an interface with the customer. The front seat was the place he sat while the salesman tried to sell him, the dash a visible symbol of the car's technology.

No wonder that information became theater inside the car: dashboards came to resemble giant versions of the radios Americans were making the centers of their living rooms and miniature versions of streamline moderne or deco movie theaters.

After Harley Earl brought styling from Hollywood to Detroit in the 1930s, instrument panels and dashboards were designed as carefully and as exuberantly as the cars' exteriors. They were little bits of Hollywood, their shadowed recesses and chrome highlights constituting a sort of film noir. Indirect lighting made information into theater, with faces and needles glowing green or red or cobalt blue.

Like theater screens in the 1950s, instrument panels and dashes grew wider along with windshields. The "panoramic windshield" was a sales point of the 1950s, and horizontal striping made the interiors appear larger and played to the American love of the horizontal.

The theater continues today: Detroit's instrument panels use all the tricks of electronics to create depth as layers of projected and "virtual" numbers hover in mysterious space.

By 1930, two conflicting metaphors began a long battle to rule the design of auto interiors. One conceives of the automobile as a rolling living room, the other as an aircraft cockpit. The former was applied largely to luxury and family sedans, the latter to sports cars.

The notion of a self-contained parlor was epitomized in the famous Rolls-Royce advertisement that boasted "at 60 mph the loudest noise is the ticking of the clock." In the 1940s the industrial designer Henry Dreyfuss commented that the seats in most automobiles were superior ergonomically and in engineering to those in the average home.

The metaphor of the automotive interior as home persists today. It can take different shape, as in the retro-inspired dashboard of the BMW Z 8 of 2000. BMW chief designer Chris Bangle compares the Z 8's dashboard to a home and the sheltering overhang projecting above the instruments, with their orange red glow, to a mantel over a fireplace. The instrument panel, he says, offers the same sense of warmth and reassurance as the fireplace.

The rolling living room metaphor focuses on the passenger; the interior as cockpit focuses on the driver. A very different BMW concept offers the cockpit as a kind of membrane, responding to the driver. The interior of BMW's x coupe, first shown at the Detroit auto show in January 2001, offers a bold vision of a dashboard whose fabric surfaces seem almost alive, shaping themselves around the driver. Built around "concealment and display," the instrument panel offers varying amounts of information by alternately displaying and hiding secondary instruments inside a mouth- or eye-like shape. It's part Art Nouveau in look, part H.R. Giger sets from an *Aliens* film— and a bit disconcerting.

Many sports car interiors, of course, play to the driver's sense of himself as a race car driver who needs the controls as thoughtfully placed as those of a fighter pilot's. Since the exteriors of so many automobile designs were inspired by the airplane it was no surprise that their interiors were as well.

From the standpoint of the driver, there were good functional reasons for the sweeping, embracing arrangement of, for instance, a Saab or Porsche interior. But Saab, the Swedish automobile maker which grew out of an aeronautics firm, also consciously made its cockpits resemble those of aircraft as much for marketing as for ergonomic purposes. In some contemporary vehicles, such as the Jaguar XK8 luxury sports car, there is an effort to have it both ways: a modified aircraft metaphor combined with the wood and leather of the luxury limousine.

Personalizing the automobile became the key priority of luxury cars. A custom car was like a custom suit—it was still for "the carriage trade." For the rest of the world, personalization took place inside the car: mechanically adjustable seats, well established by the 1950s, would eventually become electronically controlled. Multiple buttons allow several drivers to each individually adjust seats and other features and store the settings. Push a button and these return to preset locations.

In more advanced systems the car's electronics memorize everything from outside mirror settings to preset radio channels; they return to the personalized configuration with a push of a button on a key fob with a microchip inside or even, via infrared, the mere proximity of the fob to the car. More recently, Volvo has created an advanced safety concept car that automatically adjusts seat height, steering wheel and pedals by electronically reading the driver's eye position.

Clockwise from top left. The BMW x coupe concept vehicle, Audi "Steppenwolf" project, the BMW z9 convertible concept vehicle, and the Porsche Boxter

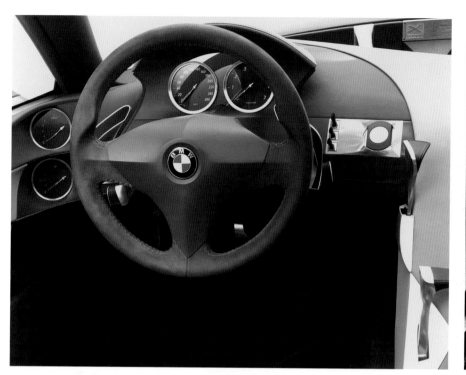
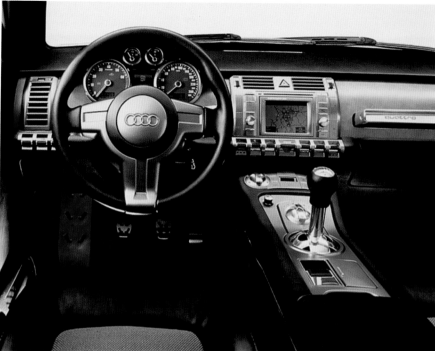
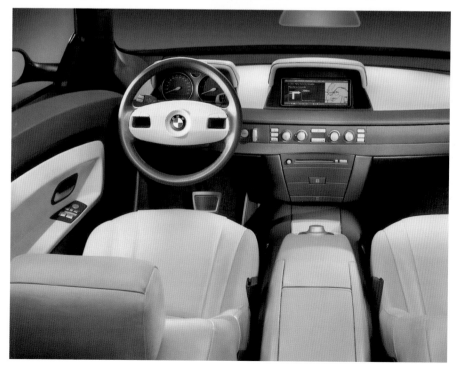
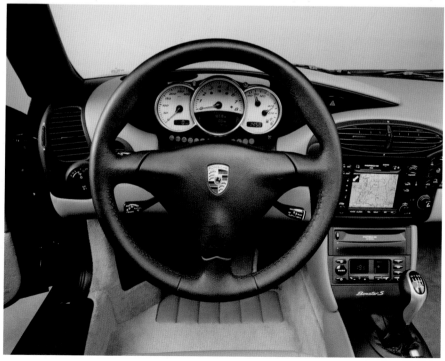

With the advent of the car radio in the 1930s, pioneered by Motorola and others, the first of a series of media arrived in the automobile. Aimed at comfort and entertainment, these have added almost exponentially to the demands on the automobile designer. In chronological order came turn signals, temperature controls (heat and then air conditioning), cruise control, sound systems, and such all-American conveniences as automatic headlight controls (first trademarked by General Motors as the Twilight Sentinel in the 1950s). Now telephone and navigation systems (with the promise of email and internet access) have forced designers in the last few years to radically rethink the car interior.

The distinctive mental state induced by long periods in the automobile was recognized early in its history. Motion, sound, and constant change did something to the normal flow of consciousness. Not long after the first superhighways were opened engineers began to warn of "highway hypnosis," a dangerous variant of the common dreamy, free-associative consciousness drivers often experience.

Technology, however, upped the ante. The famed warning on side mirrors—"objects in mirror are closer than they appear"—suggested how image and reality could become confused inside the car. But such perceptual problems would be magnified many times once electronics arrived in the cockpit, as a source of distraction and confusion.

The dangers of highway hypnosis have been joined by the problems of media distraction. The demands of portable phones, some studies suggest, increase accidents by thirty percent and diminish driver capacity as much as the consumption of two alcoholic drinks. Laws regulating cell phone use will likely spread. But even as these new media introduce serious threats, additional information devices are on the way that will likely prove even more distracting.

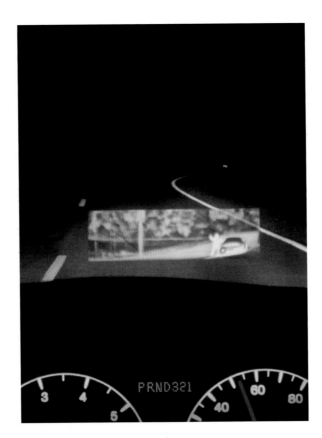

"Night Vision," Cadillac Evoq. A thermal imaging device helps make objects visible to the driver which are well beyond the range of the headlamps

In the cockpit of the military airplane, information displays are projected directly onto the canopy in front of the pilot in what is called a head's up display, or "HUD." Some helicopter pilots use helmets equipped with night vision equipment, projected instruments and other information; they are flying entirely through artificial means.

In projected displays information such as fuel supply, weapons status, and radar, the instrument panel and the world outside become integrated in a single virtual space. This space, where reality and representation mingle, is coming to the automobile as well.

The aircraft analogy inspired Oldsmobile in the 1980s to become the first to offer a head's up display in which the instrument panel gauges are projected onto the windshield. The numbers and gauges appear laid over the landscape ahead, annotating the view. More recently, Cadillac's Evoq concept car offered an advanced version of a HUD, from Raytheon, the defense contractor, combined with an infrared night vision system.

Night vision is already commercially available in Cadillacs: the night vision image is projected in a small window in black and white on the bottom of the windshield. It is eerie and disconcerting, this black and white rendition of the unreeling curves and soft distant ridges—like a glimpse back into the 1950s. Developed from early military night vision, the system is a crude forerunner of ones that will undoubtedly come.

But the airplane metaphor has its critics. Skeptical designers point out that even fighter pilots are rarely assigned to operate electronics and fly at the same time. As electronics in military aircraft became more sophisticated a second crewman was added. One designer rightly notes that "Pilots spend years being trained how to use these systems. They don't expect to jump into an airplane like a rental car and just drive off."

A more direct adaptation of a military technology presents an even more difficult interface problem. Automobile navigation units have arrived based on the military satellites of the global positioning system. The same technology that guides cruise missiles to their targets now directs automobiles. They are astonishing devices, picking routes and displaying a course of travel. To see the tiny arrow or bug representing the vehicle move along the map on a screen is fascinating; one marvels at the degree of accuracy that enables the device to advise the driver to merge right or left into the appropriate lane of the busy intersection. GPS systems can choose a convenient nearby restaurant, with cuisine and price specified; future systems will likely be linked to traffic reports and to other automobile systems such as traction control. Headlights might turn on in anticipation of a curve ahead and traction control assert itself if the driver approaches the curve too fast.

But designing a usable interface for these systems is a major challenge. Competing efforts involve sequential buttons and four-way controllers; but what is really needed is a keyboard and a mouse. Designers are busy around the world attempting to create an interface to make these things possible. BMW offers one of the most promising systems called I-drive in its z-9 concept car. (It will soon arrive in the company's top model, the eight series production car.) The I-drive system uses a joystick to let the driver navigate among information functions, from climate control to email and nav unit, by analogy to a gearshifter, segregating the imagery of the systems in a separate screen in the center of the dash.

To keep the driver's hands — already full with the tasks of driving — on the wheel, and eyes on the road, other systems resort to voice commands. Voice in the automotive cockpit is a major design issue. Early experiments in the 1980s with voices reminding drivers to buckle seat belts were quickly abandoned in the face of driver irritation. Even warning chimes wear on their users.

In Detroit it has long been held that male drivers will resist the instructions of a female voice. In Europe, the thinking is different. One Mercedes system featured a female voice whose tones recalled not a computer but the sultry actress Hanna Schygulla. Other systems employ synthetic speech devices; it is a little like taking instructions from Stephen Hawking. But even more challenging is the technology of getting the car to recognize the driver's voice — and the question of how comfortable a driver alone will be speaking to an inanimate system.

While high technology remains a major challenge, other efforts to rethink automobile interiors are more abstract. With such overwhelming practical problems of controlling equipment, it seems surprising that designers should have time to address more phenomological issues: the quality of experience in the automobile space. But oddly, dealing with the information interface problems seems to have pushed designers to also consider the social, psychological and even phenomenological side of the automobile interior in several interesting recent concepts for future cars.

Ford's innovative 24-7 concept cars, presented in 2000, were shaped around a series of abstract redefinitions of the automobile. Their prospectus defines the automobile as a "tool to navigate the day" as well as traverse the road. Noting that the average commuter spends eighty minutes per day between house and office, the 24-7 vehicle proposes ways to use that time effectively.

Its goal is personalization: the dashboard is essentially a huge screen that can be customized electronically to display information — as much or as little and of whatever type the driver desires. The 24-7's "voice-activated reconfigurable projected image display" is literally a movie screen — a luminescent sheet onto which images of instruments can be displayed as chosen by a mere word from the driver.

Ford's 24-7 was conceived with a new generation of younger buyers in mind who had grown up immersed in media. The research of Ford and other auto makers also suggested this group viewed the automobile primarily as a social space. From such conclusions, Honda developed its x concept car, whose inspiration was a "dorm room." Mazda produced a similarly box-shaped vehicle called The Secret Hideout.

Nissan also found that the social habits of young Japanese turned around the automobile. The Nissan Chappo concept was designed as a "living-room on wheels," according to Nissan's head of design Shiro Nakamura, "to be a surprising and provocative car." The design is conceived first as "social space"

Top left and right. Nissan Chappo Concept car. Designed to be more than a means of transport, the Chappo serves as a multi-functional and transformable space for people to live, work, and rest

Bottom left and right. Kion Concept car, Johnson Controls. The Kion's "instrument cluster" separates primary vehicle information from secondary information. Centered between the seats, the Kion communication center is the electronic and social hub

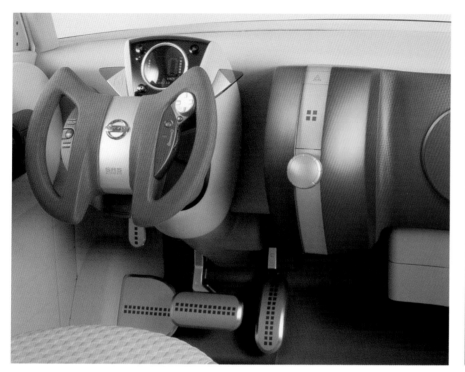
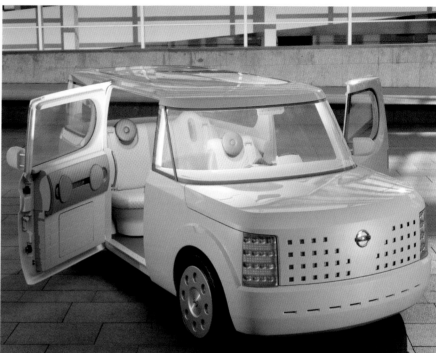
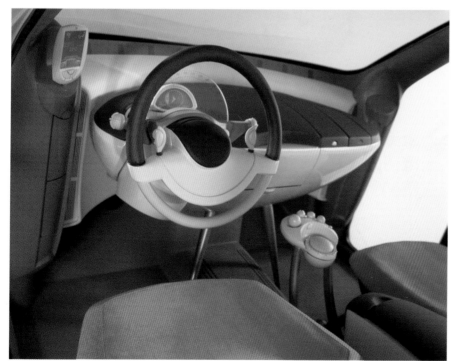
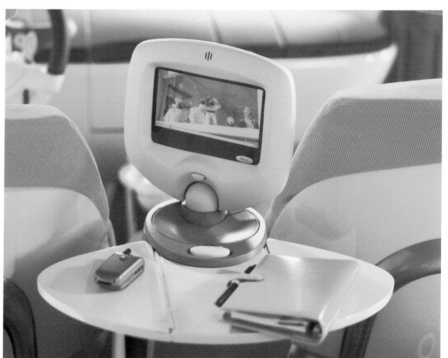

with accompanying video, audio and computer systems, and secondarily as
a mode of transportation.

The car was designed "from the inside out" for young people who use
their cars to socialize. Nakamura and his designers at the Nissan Technical
Center in Japan took as their inspiration the image of a house overlooking
a Zen garden. From the traditional Japanese tea house they borrowed round
windows and from Japanese interiors the grid pattern of the woven tatami
mat and the shoji screen.

The tatami grid has been abstracted into a motif of small squares carried
into such details as the texture of the seat upholstery and the door handles.
The motif even extends to the headlights, which are made up of an assem-
blage of LEDs resembling clear crystalline cubes. The round window shape is
echoed in round headrests and stereo speakers. Warm reds and soft grays
evoke the colors of lacquerware.

Some of the most sophisticated thinking about car interiors is coming
from suppliers of parts, an increasingly powerful element factor in
the age of distributed manufacturing and modular construction. One of the
most important of these is Johnson Controls, whose components end up in
23 million cars made around the world each year.

Working with the toy maker Lego, Johnson Controls considers the automo-
bile as a family space in the In-Motion car, billed as "the ultimate family
vehicle." For highly mobile Americans especially, the automobile has been a
critical space of family interaction, supplanting the dinner table, perhaps,
and the living room, certainly. The In-Motion divides the vehicle into adults'
and children's areas. The carpet in the front seats gives way to washable
rubberlike flooring for children in back.

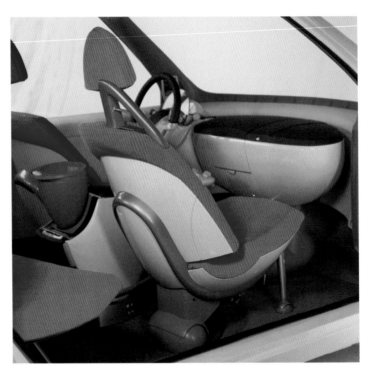

Kion Concept car, Johnson Controls. Seat
cushions and backrest can be electronically
controlled to adjust to the optimum ergonomic
shape for every body position

The In-Motion car includes an electronic table for kids, combining a DVD player with digital camera and Internet connection. The youngsters can download games and email electronic postcards of scenes snapped along the way. Adults get "Comfort Massage" seats with vibrating motors embedded in their seats. A video system links the front-seat adults with the kids in the back.

A quite different vision of the future from Johnson Controls is the Kion Concept car, a space as upright and room-like as the vehicle in Matisse's painting. It uses high technology to update the idea of the automobile interior as a rolling living room. The dashboard is now a credenza, with drawer-like storage compartments. The seats are conceived as chairs, riding on three legs each rather than rising like columns from the floor. They can rotate toward a central "coffee table" where a laptop computer sits.

In the Kion concept, each member of the family is provided with a credit card-like personal data storage unit that ties to the car's main electronic system through "infotainment system communication pillars" at the four corners of the cockpit. The electronic system provides audio, video and internet connection. Stylistically, the Kion's interior is rounded in shape, orange in color and what could be called French Futuristic in style.

Sometimes the most ambitious visions show up in surprising places. At the Detroit auto show in January 2001, for instance, Volkswagen, seeking to match the success of its New Beetle, proposed a new version of the old Microbus van. The new "microbus" does not echo the shape of the original vehicle, but focuses on the continuity from the idea of the shared communal space and the cult of the old bus, its association with the sixties counterculture, and "the Woodstock generation."

"It's an idea about space," Jens Neumann, a VW executive, said at the car's unveiling. "Useful space. Active space…space for communication and fun." This "up-to-date expression of personality and freedom" turned on the addition of high technology equipment and interior styling with translucent details. But it attempted to recapitulate a countercultural ideal of people: "to be free and easy in a space that was theirs, a space that was home."

In the new Microbus, the designers demonstrated that astonishing streak of romanticism that bubbles up at the most surprising moments from the souls of the most seemingly down-to-earth automotive engineers. They declared the ambition to give the vehicle's space "that most elusive of qualities, a soul—a soul that was in perfect harmony with the people that drove it or drove in it." A high goal, but is any lesser one worthy of a space so critical to daily life in the 21st century?

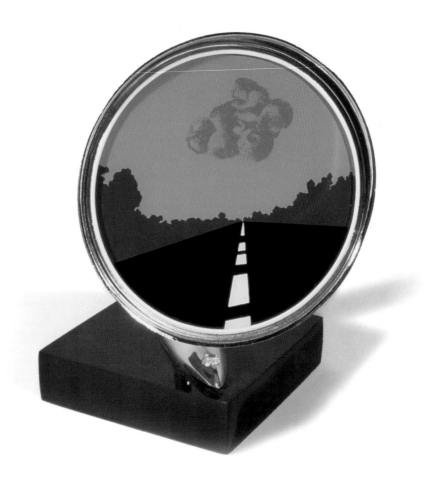

Allan D'Arcangelo, *Side View Mirror*, 1966,
Silkscreen on plexiglass mounted on mirror

PAUL ARTHUR is a professor of English and film at Montclair State University. He is a regular contributor to *Film Comment, Cineaste*, and *Millennium Film Journal* and his essays have appeared in over twenty book anthologies.

ADAM BARTOS is the author of *kosmos: The Russian Space Program—Pictures from the Future Past*, published by Princeton Architectural Press (November 2001). He is the producer and cinematographer of an award-winning documentary directed by Mira Nair, *The Laughing Club of India*.

GIULIANA BRUNO is professor of Visual and Environmental Studies at Harvard University. She is the author of *Atlas of Emotion: Journeys in Art, Architecture, and Film* (Verso, forthcoming 2001), and *Streetwalking on a Ruined Map* (Princeton University Press, 1993), winner of the 1993 Kovacs prize for best book in film studies. Her work on art, architecture, and film has appeared in numerous publications, including exhibition catalogs of the Museum of Modern Art, the Saint Louis Art Museum, and the Solomon R. Guggenheim Museum.

ANDREW BUSH was born in St. Louis, Missouri and has been living and working in Los Angeles for the past 18 years. His work is included in numerous public collections including the Metropolitan Museum of Art, the Museum of Modern Art, the George Eastman House in Rochester, and the Victoria and Albert Museum in London.

LUCY FLINT-GOHLKE is a curator at the Davis Museum and Cultural Center with a primary interest in 19th- and 20th-century photography and the role of photographic language in contemporary culture. Author of *Davis Museum and Cultural Center: History and Holdings*, her recent exhibitions include *Village Works: Photographs by Women in China's Yunnan Province*; *Urbanization and the Underclass* and *Rules of the Game*. Opening Fall 2001 is *Obituary*, an exhibition of a major work by Joseph Bartscherer.

JUDITH HOOS FOX is a curator at the Davis Museum and Cultural Center. Exhibitions she has organized include *The Body as Measure*; *RE:formations / Design Directions at the End of a Century*; *Willem de Kooning's Door Cycle*; *The Matter of History: Selected Work by Annette Lemieux*; *Who Are You? Work by Adrian Piper*; and *Empathic Economies: The Work of Lee Mingwei*.

DAVID FRANKEL is an editor in the Publications Department of the Museum of Modern Art, New York. He is a contributing editor for *Artforum* magazine, where he regularly publishes articles and exhibition reviews, and for *Aperture* magazine. He recently contributed the essay "...Remember Me" to *When This You See...: Elaine Reichek* (George Braziller, 2000).

GREIL MARCUS is the author, most recently, of *Double Trouble: Bill Clinton and Elvis Presley in a Land of No Alternatives* (Henry Holt, 2000) and *The Old Weird America* (Picador USA, 2001), a retitled edition of his 1997 *Invisible Republic*. In 2000 he taught an American Studies seminar, "Prophecy and the American Voice," at the University of California at Berkeley and at Princeton University.

PHIL PATTON is the author of *Dreamland*, a *New York Times* notable book; *Open Road*, about the American highway; and *Made in USA* and other books. He has written on design and automobiles for the *New York Times, Esquire, ID* and *Wired*. He served as curatorial consultant for the Museum of Modern Art's exhibition, *Different Roads: Automobiles for the New Century*.

TOBI TOBIAS is the dance critic for *New York* magazine and the author of over two dozen books for children. Most recently she has published *Obsessed by Dress*, a meditation on fashion composed entirely of quotations.

JAMES WOLCOTT is a contributing editor to *Vanity Fair*. His first novel, *The Catsitters* was published by HarperCollins in June 2001.

Interiors vol 1 : no 2

SOLD OUT

Rick Poynor on shelter magazines, Richard B. Woodward on brothels, William Harris on painter Paul Winstanley, Nancy Dalva on interiority, playwright John Jesurun, and Donald Albrecht on movie studios. Photographers include Robert Polidori, Duane Michals, Timothy Hursley, Jean Pigozzi, Lorna Bieber, Craig Kalpakjian, Richard Barnes, Tomoko Yoneda, John Dugdale, Jean Kallina, and Adam Bartos.

Self vol 2 : no 1

AVAILABLE 22.00 US$

Dr. Ian Wilmut on cloning, Dr. David Haig, Lewis Black, Nancy Dalva, John Kelly, Tennessee Williams, and Garth Fagan. Interviews with Maya Angelou, the Ganz Twins, and Julia Mandle. Photographers include Marvin Newman, Susan Derges, Lee Friedlander, Marcia Lippman, and Jean Pigozzi.

Uniform vol 2 : no 2

AVAILABLE 22.00 US$

Richard Martin on militarism, Alison Maddex on Playboy bunnies, Laura Jacobs on stewardesses, Arthur Golden on kimonos, Mark Wigley on lawns, Rick Poynor on Muzak, Steven Heller on doormen. Interviews with Annette Meyer, The Art Guys, Todd Oldham, and Karen Kimmel. Photographers Marcia Lippman, Graham MacIndoe, Jeff Riedl, Josef Sudek, Christian Witkin, and James Wojcik.

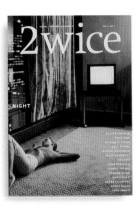

Night vol 3: no 1

AVAILABLE 22.00 US$

Nightwalker by Louis Aragon, Richard Martin on the little black dress, Joan Acocella on Bob Fosse, Anne Wilkes Tucker on Brassaï, Karrie Jacobs on Brasilia. Photographers Michael Ackerman, Brassaï, Todd Eberle, Todd Hido, Kate Orné, Jean Pigozzi, Tom Pritchard, Edward Quinn, Peter Rad, Lynn Saville, Ross T. Smith, Mark Steinmetz, Edel Verzijl, and Jay Zukerkorn.

The End vol 3: no 2

AVAILABLE 22.00 US$

Interiew with filmmaker Don McKellar, artist Charles Long, humorist Bruce McCall, souvenirs of disaster, miniature forensics, curtain calls, and fashion designer Hussein Chalayan. Photographers Jerry Dantzic, Dan Winters, Marcus Tomlinson, Jean Kallina, and Dafna Shalom.

Spring vol 4: no 1

SOLD OUT

Choreographers David Parker, Ronald K. Brown, Molissa Fenley, Stephen Petronio, and dancer Foofwa D'Imobilite. Fiction by Jimmy Gleacher, tribute to Richard Martin, Periodic Breakfast Table, illustrator Barbara Schwinn-Jordan, Meiji Kimono Designs. Photographers include Martin Schoeller, Josef Astor, Nelson Bakerman, Stephen Gill, Paula Horn Kotis, Brigitte Lacombe, Ross T. Smith, and Christian Witkin.

Ice vol 4: no 2

SOLD OUT

Choreographer Paul Taylor, Wilson Bentley's snowflake studies, Hitchcock's ice blondes, dancers Tom Gold and Banu Ogan, Elizabeth David on the history of ice and food, cryogenics, and ice carving. Artist Marc Quinn and photographers William Eggleston, Stuart Klipper, Andrew Eccles, Anders Overgaard, Gary Braasch, Larry Gianettino, Jean Pigozzi, Peter Basch and John Halpern.

Camera vol 5: no 1

AVAILABLE 22.00 US$

Choreographers Twyla Tharp and Karole Armitage, performer John Kelly, and playwright John Jesurun. James Wolcott on Minox cameras, Rick Poynor on the Lomo camera, haunted houses, Laura Jacobs' recollection of a Zeiss microscope, Tobi Tobias on Twiggy. Photographers Richard Barnes, Andrew Eccles, Stephen Gill, Arnold Odermatt, Martin Parr, Jean Pigozzi, Martin Schoeller, Richard Torchia and Jay Zukerkorn.

Right. Walter Sanders, 1941, Girl removing picnic supplies from car at Mt. Tellman Park. Photo courtesy Walter Sanders / Black Star / TimePix, NY

FOR SUBSCRIPTIONS IN
NORTH AMERICA CONTACT:

2WICE
9 West 57th Street, Suite 4210
New York, NY 10019
TEL 212 826 9600
FAX 212 826 9651
EMAIL info@2wice.org

FOR SUBSCRIPTIONS OUTSIDE
NORTH AMERICA CONTACT:

BRUIL & VAN DE STAAIJ
Postbus 75 7940 ab meppel
The Netherlands
TEL +31 522 261 303
FAX +31 522 257 827
EMAIL bruilvds@wxs.nl

NAME
ADDRESS
CITY
STATE ZIP
COUNTRY
TELEPHONE
EMAIL
GIFT SUBSCRIPTION FROM
MESSAGE
○ 1 YEAR U.S. $40 ○ AUTOMATIC RENEWAL
○ 1 YEAR FOREIGN $48 ○ AUTOMATIC RENEWAL
○ CHECK ○ MASTERCARD ○ VISA ○ AMEX
CHECKS PAYABLE TO: 2WICE ARTS FOUNDATION
CARD NUMBER EXP DATE
SIGNATURE

Next issue:
picnic

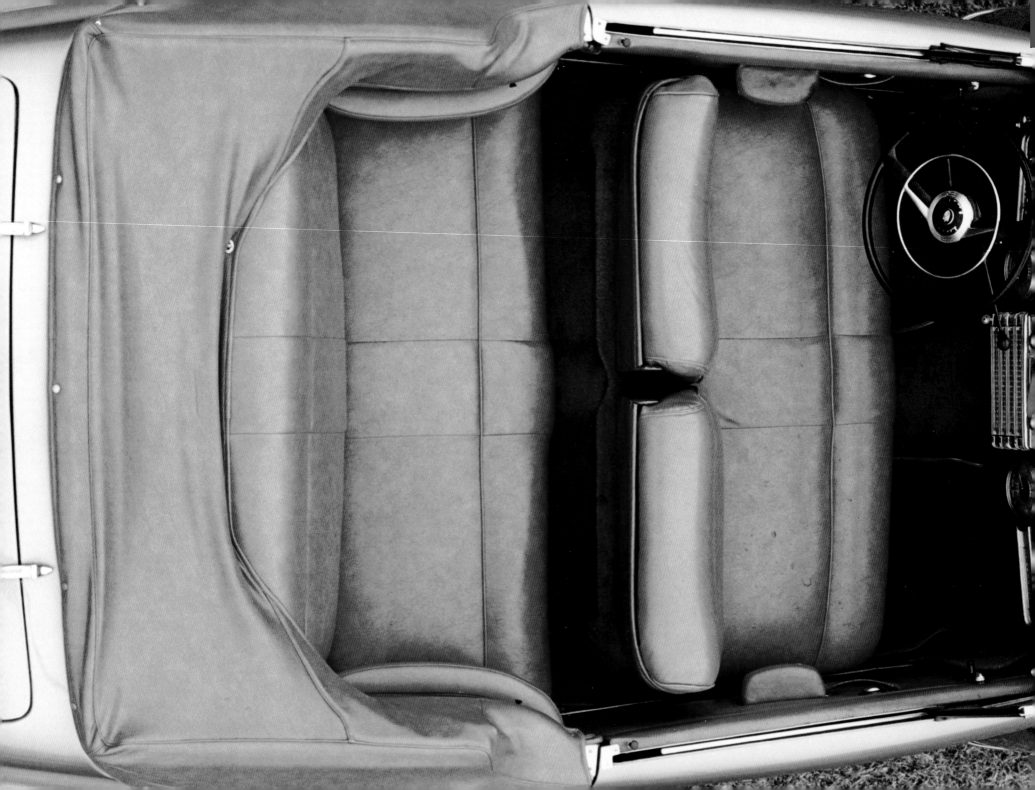